GHOSTS AND LEGENDS
OF LAKE ERIE'S
NORTH COAST

GHOSTS AND LEGENDS OF LAKE ERIE'S NORTH COAST

VICTORIA KING HEINSEN

Haunted America

Published by Haunted America
A Division of The History Press
Charleston, SC 29403
www.historypress.net

Unless otherwise noted, all images are by the author.

First published 2010

Manufactured in the United States

ISBN 978.1.59629.880.4

Library of Congress Cataloging-in-Publication Data

Heinsen, Victoria King.
Ghosts and legends of Lake Erie's North Coast / Victoria King Heinsen.
p. cm.
Includes bibliographical references (p.).
ISBN 978-1-59629-880-4
1. Ghosts--Ohio--North Coast Region. I. Title.
BF1472.U6H442 2010
398.209771'212--dc22
2010026948

To my children, Rocco Piacentino and Gina Piacentino; my husband, Ed Heinsen; my parents, Colonel and Mrs. Archie King; my friends; and my editor, Joe Gartrell. My deepest gratitude.

CONTENTS

Contents

INTRODUCTION

It has been my pleasure to collect these tales from the North Coast of Lake Erie. I am a native of Port Clinton, married to another native. Whatever prescience, precognition, clairvoyance—call it what you will—I have has passed down through the women in my family. My daughter has inherited this ability, as has my son. It should serve them well in their careers: law and sales. My husband, too, is a believer. In fact, his encouragement and experiences have been valuable assets for this book.

Port Clinton is the county seat of Ottawa County and the only city. The surrounding townships of Portage, Catawba, Danbury and Bay compose four of the twelve townships in the county. Put-in-Bay is a township as well as a village. The other villages I discuss in this book are Oak Harbor, Marblehead and Elmore. Adjacent counties are Erie to the east, with Sandusky as the county seat; and Sandusky, with Fremont as the county seat. Kelleys Island is in Erie County.

The counties of Ottawa, Sandusky and Erie have played significant roles in our country's history from before the American Revolution through the War of 1812 and into the Civil War. All three counties have also contributed servicemen and -women to World War I, World War II, the Korean Conflict, Vietnam and the wars in the Middle East.

During World War II, the 192^{nd} Tank Battalion was sent to the Pacific Theater. In April 1942, these troops were captured by the Japanese at the Battle of Bataan; many died in the infamous Bataan Death March or as

prisoners of war. Twenty-five years later, Bill Matthews in my high school graduating class, the class of 1966, was the first from our community to die in Vietnam. The last time I saw him was on the beach at East Harbor State Park, where I lifeguarded. He had come home for R&R before his second tour of duty. In high school, Bill had always been kind to me. After graduating, he enlisted; I went to college. You see, I was on my way to bigger and better things than Port Clinton. Lifeguarding for me that summer between my sophomore and junior years was a breeze; I had a terrific future.

Bill looked wonderful the August afternoon so many years ago when we met by chance. Tan, fit, he was every inch a handsome Marine, proud of his service to his country. He stopped me as I, twirling my whistle, strutted along the sand. I didn't even recognize the man he had grown into, a man very much in possession of himself and of his dreams. I'm glad he took the time to say hello. It was the last time I saw him. Bill Matthews never came home again alive.

Occasionally, I still return to the beach at East Harbor State Park. It's not the same, of course. A couple of severe storms—first in 1969 and then in 1972—changed the beach forever. A couple of storms in my own life have changed me forever as well. Come to think of it, I guess we all go through good weather and bad. In the chapter on Catawba Island, you will read how the face of Nabagon, the courageous American Indian, has been damaged by centuries of wind, rain and snow. Interestingly, a friend of ours mentioned that although that face is almost gone, a new Nabagon on an adjacent cliff has appeared. I think that is neat, and certainly symbolic if you are prone to archetypes and that sort of thing.

People ask me if I make up the stories I tell on my ghost walks or include in this book. No, these stories tell themselves. I happen to be the person standing around, in one way or another, to hear them. It is my hope that the tales will entertain and enlighten you. Perhaps, too, windows will open for you. There are wonderful worlds out there, if we just take the time to look… and listen.

PORT CLINTON

Ezekiel Haines officially founded the city of Port Clinton, Ohio, in 1837. The story goes that he first owned a hunting and fishing lodge where the Lake House Hotel used to stand. Wendy's is there now. It took his friends and him three and a half days by horseback to ride from his home in Cincinnati to "his place at the lake" Today, it takes three and a half hours by car. As with many cities in Ohio, Port Clinton has changed from a home to the location of industries, some now closed or moved elsewhere, such as Standard Products and the Matthews Boat Company to more of a tourist destination. Officially, about 6,500 people live within the city limits. During the summer, if one considers the surrounding areas of Catawba, Portage and Danbury Townships, the count rises to somewhere around 30,000. Bed-and-breakfasts, hotels, condominiums, restaurants, delightful pubs and gift shops offer tourists relaxation and fun during the summer months and the shoulder seasons of mid-April to Memorial Day and September through mid-November.

Mention Port Clinton and you will see smiles on people's faces for any number of reasons. Those folks who yearly or just occasionally drive up from regions south for a day of recreational fishing on charter boats can happily recount adventures, real or expanded with time, on the water. Sailors, golfers, swimmers, campers and owners of private yachts of all lengths think of Port Clinton as their getaway spot, the best place to go to lower their blood pressure and have a good time. Within downtown Port Clinton, the Jet Express to Put-in-Bay carries eager travelers to South Bass Island, where

they enjoy the sites and the beverages of that most famous of destinations. At Catawba Point, the Miller Ferry runs between Put-in-Bay and the peninsula. Take your pick; tourists do, and they have fun!

Because Port Clinton is nearly 175 years old, it seems reasonable to consider that ghosts and spirits are as much a part of the community as permanent residents and tourists. Whether one believes or not, a brief walk at twilight down Second Street east to Fulton Street or north to the Portage River might confirm that indeed we are not, as the more solipsistic of us may like to think, alone. Here are stories of Port Clinton.

AN OFFICIOUS ORB

People fade to spirits; spirits fade to orbs, balls of energy left behind where human beings or ghosts used to be. One such orb appropriately inhabits the second floor of the old Port Clinton Municipal Building at the corner of Second and Adams Streets. An officious one, volunteering its services, which

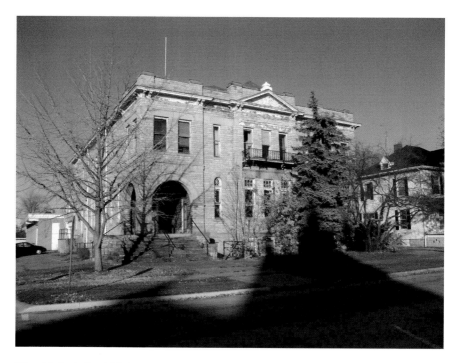

The old city hall, which housed city council chambers, the police department, a museum, a library and a jail.

are neither expected nor appreciated, the orb peers out from the former city council chambers, suggesting to onlookers that business as usual continues within the limestone edifice that until 1995 held the mayor's offices, the fire department, the police headquarters, a jail and a museum.

Perhaps this officious orb is a former candidate, unsuccessful in a mayoral bid. Or, as city council members recall with annoyance, it could be one of the many naysayers who occupied front and side seats at meetings, people who offered unappreciated suggestions or comments that contributed nothing but a waste of time for beleaguered officials. At any rate, the orb has a nasty streak; this mysterious glow disappears almost immediately after someone takes its picture. Subsequent pictures from the same camera usually show nothing but a darkened window. Things grew worse in mid-August 2009; the orb threw a tantrum, knocking out the upper casement window, which then had to be replaced by some intrepid worker who braved spiders and other rodents in the long abandoned building. More than a decade has passed with interested developers reviewing this once hub of municipal activity, but any number of reasons cause them to turn their attentions and their investments elsewhere. In the autumn, a gingko tree, its lineage linked to the era of the dinosaurs, sheds golden leaves down onto the tiny yard. Winter winds howl around corners; in the summer, all that flourishes on the property are weeds.

Actually, the entire block from Adams Street to Perry Street emits an aura that drives people away. Except for attorneys' offices located in a former funeral home, buildings and their occupants meet with, if not disasters, at least dreadfully unfortunate occurrences. An apartment in one small complex houses a rapid turnover of tenants who do not enjoy whatever opens and closes locked windows and doors at will. In fact, an official at the water office confirmed such annoying goings-on; he mentioned that no sooner had someone come out to read the meter for the new tenant than that tenant chose to live elsewhere. Mischievous uninvited spirits, earlier occupants perhaps of the framed structure, most likely vex the landlord more than they do the tenants. Nevertheless, vex they do; over the years, buildings ingest the characters of their occupants to the distress or satisfaction of the owners.

Spirits manifest their anger in several ways, among them fires. On this same block at the opposite corner where Perry Street and Adams Street meet, Port Clinton's first lighthouse, built in 1833, guided navigators to safety from far out on Lake Erie, the most treacherous of the five Great Lakes. The lighthouse was razed in 1899; a marker commemorates its significance. Here in the early to mid-twentieth century a home later divided into apartments

and a beauty shop was all that reminded anyone of the once historic aspects of this corner. Then a family of entrepreneurs bought the property, converting the building into what became a business well known for fine dining and excellent service. It was aptly named the Garden at the Lighthouse. For more than twenty-five years, the owners dedicated themselves to professional excellence but also contributed time and energy to their adopted community. Then, late at night in September 2009, a fire broke out in the basement; investigators ruled arson. But one wonders about the real cause behind this sad ending. Spirits in other lighthouses return to reenact again and again some deed that resulted in their misery or their death. Did a vengeful ghost return to this historic place to wreak havoc for some forgotten affront or just for the fun of it? The question remains unanswered; the owners work against odds to reopen their business as they accept condolences from a community that cares for them. Curious passersby may still peer through windows to tables set for dinners that may never again be served, but sadly, the Garden at the Lighthouse sits forlorn and closed.

MRS. EDNA HESS AND THE NEW NEIGHBORS

People who enjoy the additional pleasures that spirits bring to their quality of life appreciate the presence of Mrs. Edna Hess. As an efficient and no-nonsense secretary, for over forty years she served the law firm of Meyer and True. Some say she practiced law as well as her bosses; some that she practiced law even in her bosses' absence. Legend holds that clients who needed help in a hurry spoke directly with Mrs. Edna Hess; she handled matters from there.

She and her husband, Donald, never had children, but they did have each other. They lived in the house at 204 West Second Street where Edna had spent all her life. No one really remembers what Mr. Hess did, although it is thought that he sold insurance. Certainly, he did well professionally. Although the home had been built when Edna was a little girl, the Hesses kept it updated inside and out. Even after Donald died in the early 1980s, Edna continued to hire painters for the interior and exterior and contractors to upgrade other aspects of the house. First-time visitors liked to remark that they sank past their ankles in the plush, sage-colored carpet that she had installed. The house was quiet, serene and tastefully appointed with antiques and expensive furniture.

She kept the yard as attractive as the interior of her home. In the spring, pink creeping phlox cascaded down walls of her small rock garden; hundreds

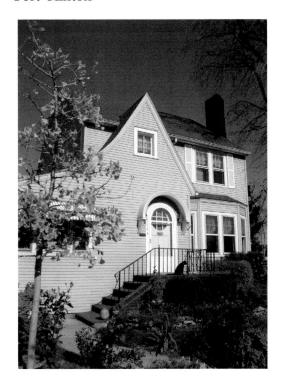

The home of Diane and Fred Pachasa. Mrs. Edna Hess's former home.

The rose Mrs. Edna Hess loved.

of grape hyacinths graced her front walk. At the age of ninety-five, she decided her landscape plan was too old, so she retained the flowers but had new holly and burning bushes brought in "to keep things nice."

Edna took a lively interest in her neighborhood as well. Despite her advanced years, she continued on pleasant summer days to carry a chair out onto her small front porch so that she could sit in the afternoon sun and enjoy the activity that a location one block from the center of town provides.

She kept her figure, too: slim, fit. She wore her hair as she always had, neatly arranged into a French twist. Edna favored the attire of a professional woman in the 1960s: dresses, accessories of jewelry, hose and shoes with small heels.

In the neighborhood, she was one of us, and yet not. She remained friendly, dignified, polite—very much a lady. According her the respect and kindness due a woman of her age and gentility, Edna's doctor paid house calls. Her lawyer visited her at least quarterly.

Sometime about 1999, Edna granted some concessions to her advancing years. Caregivers stayed with her during the day. She had her bedroom moved downstairs because the steps to the second floor became a little difficult. But other than the minor problems age brought her, Mrs. Hess enjoyed her long and prosperous life almost entirely without the plague of ailments that afflict people her age. In fact, although nearly one hundred at the time, she seriously considered attending a cousin's birthday party in Indiana, some four hours away. She didn't go, but she wanted to. She thoroughly loved her life.

After a few brief hospital stays in 2002, Mrs. Edna Hess died quietly, at peace with herself and her world. Her impeccably maintained home and yard passed into her estate, thus opening the door for Fred and Diane Pachasa, Cleveland residents who always liked Port Clinton, to move in. One of those handymen who remodels "for something to do," a fellow who can fix almost anything, Fred is accustomed to the quirks that come with old houses. His wife, Diane, loves to garden, so for this couple, Edna's house seemed perfect.

Now, Edna had been meticulous: she wanted things done just right. A few years before her death, she had requested the landscapers remove three or four bushes she had, only a month previously, ordered planted. They just weren't doing well, and they were not quite what she had anticipated. Apparently this tidiness, this attention to detail, attracted the Pachasas to the home but also guided their remodeling efforts. Both Diane and Fred worked sedulously to update their new house but also to keep it the way they hoped

Edna would like it. Today, the entire house is upgraded for the needs of a professional couple in the twenty-first century.

They do have one problem, however. Edna, always one to take a lively interest in her neighbors, returns occasionally to the house she had lived in since her girlhood. Fred and Diane are believers, so a spirit manifesting its presence would be noticed and appreciated. That first year the Pachasas settled in, they were in the living room watching television one evening. Fred noticed a ghost walking down the stairs. Assuming it to be Mrs. Hess, both he and Diane greeted her and then returned to the TV program. It's rather simple, really: when someone else is in the house, in this case a kindly spirit that bothers no one, accept it as part of life and continue with your own.

But not only do the Pachasas blithely accept her presence, they also delight in her sense of humor. Edna turns a light on in the third-floor attic whenever she visits. At first Fred, having repaired more electrical problems than he can remember, felt mildly annoyed with the light's intractable behavior. He or Diane turned the light off; a few minutes or hours later, it came back on. They switched it on; it went off. The couple admits that it took them a while to understand her pervasive behavior, but as with most people who live with ghosts and spirits, the Pachasas greet Mrs. Hess politely and then go on about their activities.

In a curious but pleasant sort of way, Edna continues her presence too in the front yard she so enjoyed. A rosebush with delicate pink blossoms grew at the side of her garage; after her death, the bush withered almost, but not quite, to death. Diane and Fred moved it to the front of the house, near the winding sidewalk in full view for Edna as she sat in her chair there on her porch on a sunny summer day. Deep into the fall the rose still blooms; its color is the delicate complexion of a lady, beautiful even into her nineties.

One final thing bothers the Pachasas, however. First combing through the remainders of an estate sale and then requesting pictures from relatives, friends and organizations to which she belonged, they have been entirely unsuccessful in finding even one photograph of Mrs. Edna Hess. Is she unhappy with her appearance? Is her hair not exactly as she wished? Or is she making sure that when she does present her gift to the new neighbors, who honor her life and respect her property, that everything looks perfect, just the way she prefers?

THE HAUNTINGLY BEAUTIFUL
HIGH SCHOOL STUDENT

Port Clinton High School opened its doors in 1963; the old high school at the corner of Madison Street and Fourth then became the junior high, now known as Port Clinton Middle School. It is at this aging brick edifice, a monument to what is called the International style of architecture so popular for public buildings erected in the 1920s, that the ghost of the Hauntingly Beautiful High School Student has appeared.

Whether she was running late to class or wandering the halls as she looks for a lost boyfriend, the custodian she startled could not say. This, however, is how she appeared. It was late one evening. Greg, we'll call him, had been working the graveyard shift, that time between 11:00 p.m. and 7:00 a.m. when Port Clinton is dark and still. High school students who wrestled with homework, or neglected it, had long since been asleep; middle school students tossed and turned, unaware that the school they would reluctantly or excitedly attend the following morning was a familiar building to our lovely wanderer.

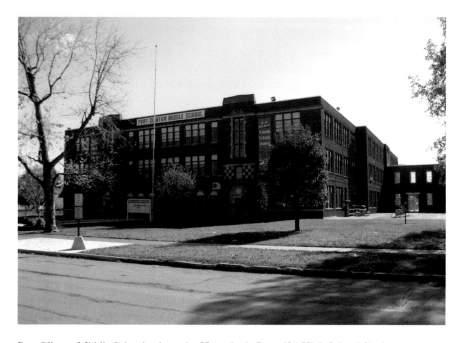

Port Clinton Middle School, where the Hauntingly Beautiful High School Student appeared.

Greg worked alone that night, quietly emptying trash, sweeping the floor and making small repairs as teachers had earlier requested. But something stirred him from his routine, causing him to peer down a second-floor hall toward a presence that drifted ever closer to him. "She was beautiful," he recalls, "dressed in a red blouse and black skirt. She floated toward me." She floated, you see, because she had no legs.

Greg's story alone is frightening enough, but the consequences he suffered for "telling tales out of school" are even more frightening. He recounted the tale of the Hauntingly Beautiful High School Student in the spring of 2006. During mid-August of that same year, I greeted Greg in the post office, asking him cheerfully if he was ready for another school year. "I'm not going back," he glumly commented. "Something happened to my knees. The doctors don't know what caused it, but I can't walk very well. I had to retire." With that, he turned dejectedly and limped away. Whether the spirit of a high school girl with a bad temper and a thirst for vengeance punished a good, kind man for narrating a rather innocuous incident or whether Greg's knees gave out suddenly from other causes, we do not know.

What we do know is that Greg has turned to another, more spiritually fulfilling career. After his retirement from his custodial position at the middle school, he embraced a more ethereal life. You can find Greg most Sundays where he pastors at a newly painted little white church in an older section of town. The only ghost he has ever wanted to deal with he deals with now: the Holy Ghost.

As I often remind guests on the ghost walks I guide, things happen that we cannot explain. Greg's granddaughter flew in from Florida to stay with her grandfather for a week or so in the summer of 2009. For no apparent reason, she was drawn to my ghost walk; neither she nor I knew of her connection to the Hauntingly Beautiful High School Student until we approached the middle school and the story unfolded. Greg's granddaughter capped the tale with a final remark. Her grandfather's mysterious affliction has disappeared. He walks today without a limp. He is, indeed, a healthy man again.

During the lunch period, elementary children's delighted cries drift up from the playground adjacent to the middle school. On beautiful autumn days or those late spring afternoons more than one upper-level student, deemed too old for recess and who certainly would never be caught actually playing, has probably daydreamed instead of paying attention to the lesson. It's easy to do; I suspect the teacher who happens to continue the lecture as he or she moves over to the window lets their mind wander as well. What

draws teachers' and students' longing gazes other than the fine weather and the knowledge that they could be elsewhere?

The first high school building stood where the playground is now. My grandmother attended what we knew later as the East Building. Along with several of her friends, she quit school in 1902 because they didn't like the teacher. Sometime in the mid-1960s that building was razed; the other two schools remain: Jefferson Elementary and the middle school. Several years ago, about midnight, a custodian's wife arrived at the usual time to pick up her husband. To make idle conversation, she inquired about a meeting at Jefferson. While waiting for her husband, she witnessed six or seven men in suits and ties departing from the school. "Why did they meet so late at night? What was the occasion?" she asked.

"There was no meeting," her husband replied. "There was no one in Jefferson." But the school had opened its doors in 1953 to accommodate the first wave of the Baby Boomers entering kindergarten. Standard attire for men in the 1950s was a suit and tie. Most likely, the figures the custodian's wife viewed were ghosts of that school board that oversaw the building of Jefferson Elementary.

Within those same years another spirit, a female with shoulder-length black hair in a pageboy style, wandered the middle school, perhaps searching for her books or her boyfriend. Children's delighted voices echoed through the halls long after school was over, deep into the night when no one but the maintenance staff was present.

Fortunately for students, their families and the staff of Port Clinton City Schools, in November 2009 a bond levy passed. Jefferson Elementary and the middle school will be torn down; a park may be planned to replace these buildings long overdue to be razed. Will the ghosts stay or will they wander off, finally giving up on locating a locker, a boyfriend or a homeroom? Those ghost children in and around the middle school, though, will still have a place to play in the green space where buildings from another century used to loom not so long ago.

The Lonely Divorcée

Veronica Richard's asperity toward people she did not like was legend. But for people she liked, she literally would do almost anything. A talented artist, an excellent dancer and intelligent as well as attractive, Veronica, we'll call her, graduated from Port Clinton High School with the class of 1966. Our

Veronica Richards winks at the gentlemen she fancies with this light. The Port Clinton Yacht Club appears across the river in the background.

town in the '60s was too small for her; she left shortly after graduation to carry on with a life most of us heard about through the few friends she still kept in touch with. There was an assortment of jobs, all of them beneath her abilities, a few marriages, no children we knew about; then, around 1990, she came home.

Some said she returned to care for her mother who was dying of cancer. Others wondered if it were merely an excuse; those two had never quite ironed out their mother/daughter difficulties. For once, though, Veronica seemed to have settled down. She sedulously attended to her aging parents, visiting her mother in the hospital and then tending her at home and cooking for her father, a retired family physician. Cleaning houses, assisting customers as a clerk at a local jewelry store, Veronica also accepted part-time work with the grace and dignity that used to be seen when she carried herself through the halls of Port Clinton High School nearly thirty years before.

But Veronica's demons tore away at her. She loved the Port Clinton Yacht Club, which she had joined in the 1990s when it was decided that single

female members were no longer a threat to the family atmosphere of this nearly century-old organization. It was there that Veronica's dual natures of petulance and great kindness drew tremendous gratitude or tempered excoriation from the board and the club members. I am told that she was a routine item on the bimonthly agenda, as flag officers and trustees threw up their hands over yet another of her escapades.

Alcohol, more than anything else, most likely caused her mood swings, along with her sometimes obstreperous behaviors. She did not hesitate to stalk over to new members or guests, acidly remarking to them that they were sitting in "her" chair at the bar. Glowering at the hapless interlopers she waited, like a cat, until they moved or left. Veronica liked the gentlemen, too. Rumors of her flings with various members may or may not have been true. Nevertheless, a wife was hard put to recapture her husband's interest when Veronica turned her glorious smile his way.

What drove board members nearly crazy was what also engendered in them a certain admiration for her. Veronica loved the club; she loved the members. Anything she could do to help, she did, from scouring kitchen cupboards after a greasy fish fry for three hundred people to painting dock stakes during a cold October morning. It was Veronica who chaired the New Year's Eve parties; everyone else was married or too busy with their families during the holidays to commit to an event involving substantial food, elaborate decorations and a live band.

Over the years, her disease caught up with her. Veronica grew thinner and thinner; her thick black hair turned a brittle gray. She looked much older than her fifty years. Silent, waiflike, she drifted through the club, a ghost before her time. I owned a cleaning business that had been contracted those last few years to clean the Yacht Club. No one except the caretaker along with my husband, Ed, and I was permitted in the building before opening hours at 3:00 p.m., but Veronica usually managed to sneak in. In a puerile attempt to thwart her, we three employees not only made sure all the doors were locked but also piled up chairs, propping brooms and buckets in front of entrances. But Veronica always found a way in.

We used to joke in those final years that we couldn't keep her out when she lived; we certainly should not expect to keep her out after she died. And die she did, a very sad death late on Halloween night in 2002. Veronica was on dialysis at the time, but she still drove herself to the club for the medicine that mattered most to her—gin. She stayed well into evening and then navigated her newly purchased used car home, where she lived with her widower father. Apparently, between the garage and the back door she stumbled and

fell as she walked, probably unsteadily. Everyone in the neighborhood slept; her nearly deaf father could not possibly have heard her cries for help.

Veronica lay on the frozen ground all night; she died of hypothermia. She was fifty-four.

It didn't take long, though, after Veronica was buried for her spirit to return to the Port Clinton Yacht Club and the bar that was more her home than the contemporary Perry Street house across from the lake. While she lived, she had a favorite bartender who was kind to her; how many hours they watched television together in the often otherwise empty bar those many years, who knows. A lonely divorcée, Veronica must have carried the weight of unfulfilled wishes on her thin shoulders the way high school students overburden themselves with backpacks today. James, we'll call the bartender, listened to her; he helped her as much as he could. But the time came when Veronica just could not help herself anymore.

She continued to visit the club for several years after her death. Temporary bartenders, hired when the regulars took vacation or sick leave, have seen her. Possibly, members have as well, but the lateness of the hour and their own conditions may keep them from mentioning any fleeting apparitions. Her chair still remains. Although seven years have passed since her death, most people still avoid it. Even new members who never knew her defer to the spirit that claims that barstool for itself.

There are a few other places Veronica visits. Extraordinarily curious, like the cats she kept, she was seen on an adjacent porch observing the new owners move into the house where she had once lived. Her father died shortly after she did. Like her dad, the new owner is a doctor, practicing at the hospital where her dad had worked, where Veronica also volunteered those many years before as a candy striper, dreaming, I recall, of being a nurse.

You can also find Veronica some nights at the Jefferson Street Pier along the Portage River. A few hundred feet across the river is the Yacht Club. People on ghost walks enjoy the tale of Veronica; they may even reflect on how their own lives take turns they had never anticipated. As I tell and retell Veronica's story a streetlight overhead blinks and then blinks again. I have long since become accustomed to it. The ghost walkers are stunned. But it's only Veronica; she loved attention. And she loved the gentlemen. So far, she has only "winked" if men are in the group.

TWO MURDERED GIRLS

Ezekiel Haines founded Port Clinton in 1837. Still considered a village twenty-five years later, Port Clinton remained a rural community where peach and apple farmers brought their produce to market on what is now Madison Street. On Saturdays, wagons lined the packed dirt of downtown as buyers selected their wares and farmers and their families exchanged gossip.

Many of those names from 175 years ago continue to be part of the community. Some farms in the townships of Catawba, Danbury, Bay, Portage, Benton, Carroll and Salem remain, perhaps smaller, perhaps eclipsed by country-style houses or planned unit developments, but the careful observer can still delight in relics of not so long ago. Within the city of Port Clinton itself, one can observe garages that were once barns, outbuildings still used as storage sheds and a former blacksmith shop on Sixth Street that is now part of a house. Second Street extends from a few hundred yards south of the Portage River, east to what is now a small shopping center. An energetic exerciser can walk the distance in less than twenty minutes. Huge maple trees more than one hundred years old were planted along this now residential street to provide shade for those long-ago people in horse-drawn carriages.

Most of the larger two- to three-story homes from Washington Street six blocks east to Hayes Avenue were built in the 1920s or somewhat earlier. Before that, there were farms as close to town as five city blocks now. On one of those farms, two little girls left in the care of their trusted babysitter were violently murdered.

A newspaper account from the era describes the crime. Mr. and Mrs. T.J. Kirk had taken their older son with them when they visited friends in Elmore, Ohio, about twenty miles to the west. For whatever the reason, possibly because their hosts simply lacked room, the Kirks left their daughters Naomi, age fifteen, and Amy, age eleven, in the care of a young man, Henry Riquartz. At thirty-two, Henry was considered trustworthy, wise and informative. Apparently, he worked on the Kirk farm, which included a home on what is now Perry Street and a granary. A large home replaces the silo now; the address is 529 East Second Street.

The Kirks departed for their journey on Friday morning. Sometime in the afternoon, Alice, a frequent visitor and apparently an adopted daughter of the Kirks, went to the home to visit. Upon entering, she found the table set as if lunch had been eaten. She called for the girls but, hearing no one, walked into the yard and out into the barn. Still finding no one, she returned to the house, where she encountered Henry Riquartz, who had gathered a pile of

his clothes and seemed to be leaving. Alice assumed that he was taking his items to the village of Port Clinton to be laundered.

She asked about the girls, but Henry lied about their whereabouts. He then suggested that she should rekindle the fire, which had gone out, as dinner should be prepared. Evidently, Alice turned to start the fire when he seized her by the throat and strangled her. She fought, but he overpowered her, tying her up but not killing her. He explained that he did not wish her dead; he only wanted her out of his way, as he had murdered the girls and did not want her to tell anyone. Leaving her secure in the house, he departed. Shortly thereafter, he killed himself.

Seeing Henry some distance from the home about an hour before his death, a neighbor woman inquired of him as to the whereabouts of the little girls. Probably not believing his response, the lady searched the farm, where she discovered the bodies of the two children. They were in the granary; they had been garroted by a leather cord.

A coroner later placed the time of death, the first murder in Ottawa County, at about noon to 1:00 p.m. on October 31. The little girls are buried in LaCarpe Cemetery in Bay Township, about three miles outside what are now the city limits of Port Clinton.

But the spirits of these children so brutally murdered remained in the granary even though a new home replaced the silo. Residents in the 1950s and 1960s often heard voices and footsteps in the attic. At least once, a little girl with long hair appeared, dressed in bedclothes. The murdered children had been discovered in nightwear. On Halloween about 2002, three figures—a woman supported on either side by a man—appeared at the bottom of the main stairway that leads to the attic. Most likely, this ghost is the mother of the girls; one man would be her husband and the other probably the children's uncle, her brother. That bleak day in 1862, the family had been summoned from their vacation in Elmore. One can only imagine the horror and terrible sadness felt, particularly by the mother. In keeping with the writing style of the day, the newspaper article touched so very delicately on what else may have happened to her beloved daughters. All three of the ghostly figures wore the black formal attire of mourning in the nineteenth century.

The current residents of 529 East Second Street believe that by now these children's spirits have passed. There has been no activity for the last few years, and for that, they are happy. "I hope," reflected Lenore Frederick, who lives in the home with her family, "that they have found peace."

MOTHER EVERS

As a kid, I called her Aunt Elsie; my mother addressed her as Mother Evers. A widow by the time I knew her, Mrs. Evers lived two houses to the north of us on Washington Street. She didn't work, but in the 1960s, not many women did; besides, in my juvenile mind she was old. Old people did not work. It was only after her death that my mother commented in passing that she wondered how Aunt Elsie survived, how she paid her utilities, where she got her food. Aunt Elsie had been broke, it seems, for years.

Her home was lovely inside, though, with varnished woodwork everywhere. An impressive staircase led to the second floor, where dark mahogany furniture crammed three bedrooms. What I loved most, however, was the stairway's polished banister; both Mother and Aunt Elsie encouraged me occasionally to slide down it, and I did.

Each year during the lull in the week between Christmas and New Year's, Mother, my grandmother, Aunt Elsie and I gathered for lunch at the Island House, a grand old hotel in downtown Port Clinton. Lunch was fun, but

The home of Mother Evers, where she still affably chats on the phone.

the boring part came next, lasting interminably late into the afternoon. Following the midday meal, all four of us would traipse to one another's homes, where we displayed and discussed our gifts, which were still kept under the Christmas tree for this ceremonial tour. Why I was included I couldn't understand, but for years I obliged by lumbering along without much fuss as we carried on with tradition.

Upon returning for the holidays during my freshman year in college, I probably acted so obnoxious about the whole routine that rather than put up with my puerile attitude, Mother made a wiser choice: leave me out since I complained so much. I really had better things to do; I had discovered what I considered a much more sophisticated world. The three of them, Mother, Grandmother and Aunt Elsie, continued their tradition; I graduated with a head full of learning and not much sense, married and forgot about the annual Christmas lunch that meant so much to my family and my friend.

Deep in the winter of 1973, Mom called to tell me that Mother Evers had died. Because of Aunt Elsie's advancing age, my father daily checked on her, dutifully walking a few hundred feet down the block to her home. Apparently, he brought food too. One day he found our aged family friend slumped next to her telephone, the receiver having slipped from her hand. She was buried a few days later from the church she loved, St. John Lutheran, located one block west of her house. Mother advised that it was not necessary for me to attend the funeral.

Sometime later that summer when I returned for a visit, I learned— almost by way of the back door, as we say in Ohio—why my mom had called her Mother Evers. Aunt Elsie's only child, a son, had been engaged to my mother in the early 1930s. Handsome, a smart dresser and unfortunately a drinker as well, Ellsworth Cleaver was killed in an automobile accident shortly before the wedding. Had Mother married him, I would have been Aunt Elsie's granddaughter; Mom would have been her daughter-in-law. Instead, Mother Evers, whose husband died in the 1950s, leaving her a legacy of unpaid bills, faced the next twenty years of her life alone.

What she had though, she clung to: her church, her friends and her telephone. A faithful member of St. John, active within the ladies' groups, a weekly attendant at Sunday worship, Aunt Elsie derived as much joy from the church as God provided. She stayed in touch, too, with her many friends. It's hard for young people now to understand how a house could have only one telephone—and a stationary one at that. But it cost almost nothing for Elsie Evers to delight in her phone, her entertainment, as she visited hour upon hour with the ladies of Port Clinton.

It seems only natural, then, that the family who bought the house and renovated it after her death would enjoy her company from her afterlife. The little girl of the family grew up hearing Mrs. Evers, quite regularly, chatting away, she says, on that one telephone just under the varnished stairway.

At St. John Lutheran Church, two stained-glass windows behind the altar bear her name, Elsie Zeller Cleaver, and the name of her beloved son, Ellsworth Ferdinand Cleaver. Had he lived…well, at Christmastime, I look back those many years at my mother's love and dedication to Aunt Elsie, Mother Evers, always in my mother's life and in her heart.

PARLIAMENT

My friend Jane recounted this tale one January afternoon on her hurried trek from one meeting to another. "You can write about me, but don't mention my name," she cautioned. "People will think I'm crazy!" Well, Jane, here is your story, and as promised, I changed your name.

In the 1970s, when she was first married, Jane and her husband rented an apartment in a newly constructed building on Fremont Road on the outskirts of Port Clinton. The city was still expanding; the area where Jane and Dan lived had only a few years before been farmland. Before that, it is hard to tell.

As with many of us then who had only recently been warned about the dangers of cigarettes, we ignored the news and continued to smoke. So it was with Jane, who to this day also sedulously embraces routines. Each evening before retiring, she placed her cigarettes on the nightstand; each morning she reached for them, only to find them annoyingly placed somewhere else. Dan didn't smoke; an organized accountant, Jane insisted on precision. Who moved the cigarettes?

In those years long before talk of ghosts or Native American spirits had entered our casual conversations, Jane questioned Dan, a respected attorney who knew a little something about titles and history: "Was something buried here? Something keeps moving my cigarettes!"

Jane and Dan moved out of the little apartment on Fremont Road and on with their lives. Jane still smokes but not as much. And she has chosen a brand different from the one she used to like, back in the day, as we are fond of saying in the vernacular. Oh, and Parliament, the ghost she named after her cigarette of choice in the 1970s? Jane suspects it still might linger in the apartment, particularly if the residents beckon it across the misty haze of late-night tobacco smoke.

RAILROAD DISASTERS AND TRAGEDIES

Train tracks crisscross much of Ohio, an important state to the railroad industry. Although only a small city, Port Clinton lies on a major thoroughfare between Chicago and New York City. When my grandmother was alive, she used to take the train to meet her cousin in Erie, Pennsylvania. The train no longer stops in our community, but travelers can drive fifteen minutes to the east to Sandusky or forty minutes to the west to Toledo and still enjoy the benefits, if not the relaxation, of travel by rail. Granted, unlike England and Europe, where the trains run on time, a U.S. passenger expects and endures long delays. But trains remain an important element of transportation for both leisure and commercial ventures.

The railroad bisects the heart of Port Clinton; there is no "other side of the tracks." Perhaps this accounts for the following three disasters, all of which occurred in the same vicinity. Interestingly, all three accidents happened adjacent to or in the nearby vicinity of what was first a funeral home. In the mid-1950s, a woman whom we will call Carolyn lost her grandfather to a car/train collision on the tracks two blocks from West Third Street. Then, in 1981, the Riznikov family purchased the former funeral home on West Second Street as a residence and photography studio. They had not yet moved in, but Al and his wife, Carol, were preparing for a shoot when Carol looked out the window at the tracks on the landscaped hill a few hundred feet away.

She remained calm, the way people sometimes do when time stops. Remarking to her husband as freight cars overturned onto the Riznikov property, she observed, "I believe that train is coming down the hill." It certainly was. With a terrible rumble, over four hundred tons of coal being hauled to a power plant spilled onto the ground a few yards from the studio. No one was injured, but they were very very surprised.

Unfortunately, a few years later, another family experienced tragedy in this very same location. A little boy a few houses down on West Second Street wandered up the hill to play. Railroad tracks are fascinating to children: the shiny rails, the smell of the ties, the gravel between the tracks. Surely living in Port Clinton he must have heard how a kid can put his ear to the rail and hear an oncoming train miles away. But the train was not miles away. In his happy exploring, the little boy, lost only for moments from his family that searched for him, was struck and killed.

Looking back at these three events, all occurring in the same vicinity, one wonders, truly, if an unseen hand, merciful in one instance, cruel in two others, orchestrated circumstances. Does a being haunt the area?

Late one night in July 2009, a guest at the Marshall Inn remembered something she wanted from her car. She quietly crept down the steps to where her van was parked in front of the garage. At the corner of Second Street and Monroe, the inn is two houses—or about five hundred yards— from the tracks. Roxanne, the guest, her girlfriend Linda and their teenage daughters had decided on a whim to come to Port Clinton. Linda had long been a believer in the paranormal, but Roxanne had her doubts. Those doubts fell away quickly as, at about 2:00 a.m., Roxanne, unlocking her van, happened to glance up at the garage windows. She gazed in horror at flashes of light, orbs, dancing across the garage door.

"It was horrible!" she offered the next morning at breakfast. "I never want to go down to that driveway at night again, no matter how much I want my cell phone charger!"

Two months later, Roxanne and Linda returned to the inn, this time with their respective boyfriends. It's nice sometimes to have a man around the house. There may have been orbs in the garage window that night as well; the ladies and their gentlemen, however, were busy elsewhere.

Whatever ghosts lurk in the neighborhood by the Marshall Inn or the house that was once a funeral home seem to randomly appear to do whatever they wish. They come and go as they like, but it is best to acknowledge the possibility of their power and to try, if one can, to avoid being caught in the vortex. Look for these beings; you will not find them. Be forewarned, though, that they surely exist. Shakespeare's King Prospero said it best: "These our actors, as I foretold you, were all spirits, and are melted into air, thin air."

THE ISLAND HOUSE

Close your eyes for a moment and think back to what a grand inn may have looked like one hundred years ago. Think of Italianate architecture of glorious red brick with white wrought iron, trim white shutters at each window and a majestic staircase just off the inviting lobby beckoning weary travelers to a night of rest. You have the Island House Hotel and Restaurant as it was when it was first built in 1886 and as it is now.

An advertising flyer gives the history of the hotel. The original proprietor, Conrad Gernhard, was also the local sheriff. His son later managed the inn until 1921. Many older Port Clintonites remember more recent owners Otto and Marie Stensen, who presided over the Island House sometimes with an iron fist, at least where their employees were concerned. Other younger folk

recall the historic Paul Clemons family, who later owned the hotel and lived in their large apartment right there at the inn.

What we know from history is that famous guests stayed at the Island House, many to oversee the building of their luxury yachts at the Matthews Boat Company just three blocks to the west on the Portage River. Among those guests were Humphrey Bogart and Lauren Bacall, Clark Gable, Joe DiMaggio, General Douglas MacArthur, Bob Dylan and three U.S. presidents.

Given the age and the inviting atmosphere of the inn, wouldn't you expect ghosts to float through now and then? And so they do! People who see them are, of course, employees, just going on about their work while sometimes bumping unexpectedly into otherworldly folks as well. Apparently, the ghost of a maintenance man with a tool belt wanders haphazardly through the inn, making routine repairs, I suspect, just seeing to it that things remain in apple pie order. In the restaurant, one of the servers reported seeing a lady attired in fine clothing from another century.

But the most fun are the partying ghosts on the upper floors. One winter night about fifteen years ago, a former manager and her family drove down from their home in Toledo, about forty miles to the west, to check on the hotel. When they left home, a light snow fell. That little squall had turned into a blizzard by the time they reached Port Clinton, with roads closed and icy conditions preventing further travel.

The desk clerk indicated that any of the rooms was available; no one was there midweek in January. The next day, Karen, we'll call her, and her family ambled down the long staircase to the checkout desk on their way to the car and home. Out of courtesy, the clerk asked them how they had slept.

Exhausted and rather cross, Karen retorted, "You might have let us know there was a big party going on upstairs! People laughing, music playing, glasses clinking! I couldn't sleep at all!" You, dear reader, have stayed with us long enough in this book to know the clerk's reply. There was no party; there were no other guests.

Well, blizzard or not, what are ghosts to do on a chilly winter night except enjoy a few *spirits* of their own? It just seemed the thing to do at the time.

PORT CLINTON FISHERIES

At 2 Madison Street on the Portage River, Port Clinton Fisheries—originally owned by the Lay family, one of the historic and generous founders and supporters of our city—remains a working symbol of the heritage and

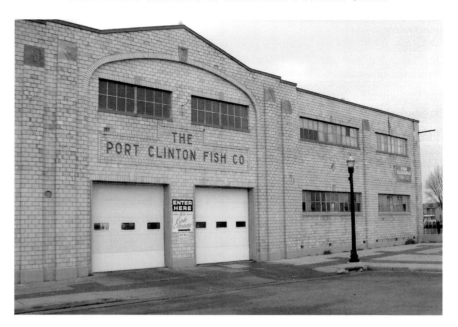

Port Clinton Fisheries on the Portage River.

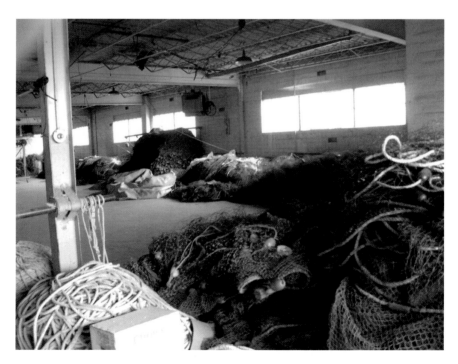

The second floor of Port Clinton Fisheries, where ghosts still mend nets and tend to the important business behind fishing.

business still so important to the community. The company passed to the Stinsons in 1973. With justifiable pride, Mr. Lee Stinson remarked that on December 31 of that year he put one half of the sale price down; on New Year's Day 1974 he paid the remainder, and Port Clinton Fisheries has operated on his and his family's honest and hardworking watch ever since.

Today, thirty-seven employees fish commercially as the law allows. Lee himself started work officially sometime in the 1960s. Along with his son Rich, he operates four boats of his own during the season. Mr. Stinson reflected on the early fishermen who combined fishing and farming to make a good living for these two industries that served as cornerstones in building Port Clinton. As with the Lays, the Stinsons have paid their workers well, treating them as valuable members of the family business, and the employees have remained with the company for years.

When I talked with Mr. Stinson in late November, a boat was due in shortly, bringing a load of whitefish to be sent to New York City. Huge nets haul in thousands of fish, which are then immediately packed on ice to maintain freshness and then quickly transported back to the dock.

"The beauty of whitefish," Lee commented, "is that they float." They also smell like cucumbers. With the aroma of a delicious salad, they are beautiful indeed, measuring about twelve to sixteen inches or somewhat longer, and are the premier entrée in many eastern cities in the United States. Eggs from the female provide caviar as well, but the day I visited, November 24, was the cutoff day for shipping. "It's not good after that," Mr. Stinson offered, fiercely overseeing the continued quality of his product.

In the summer, sport fishing contributes extensively to the company income. Charter boats, called head boats when they carry ten to thirty people or more, motor a few hundred yards down the river into Lake Erie. Smaller boats averaging four to six passengers venture out into prized grounds, all with the goal of giving their hopeful clients their limit of tasty perch or the larger, highly sought-after walleye. Landlubbing tourists to the area eagerly pay $18 to $30 in fine restaurants for the same dish, so clients who catch their limit of forty yellow perch or six pickerel, even though charter fishing on a private boat may cost up to $400 to $600, find justification and fun for their day on the water.

Port Clinton Fisheries not only cleans the bounty these lucky sport fishing fans bring in, but it has also been known, more than once, to go the extra mile, be it land or nautical, to ensure a happy visit to our community. Despite captains' and their first mates' best efforts, sometimes the weather and the fish do not cooperate. It is then that disappointed clients find another way

to success, and there is, we know, always another way: they buy the perch or the walleye right there at 2 Madison Street. Then, added Mr. Stinson, they ask him to throw a fish to them while one of their friends snaps a picture. Grinning, they leave content: "Now we've caught some fish!"

Nets for commercial fishing are expensive and need constant maintenance. Port Clinton Fisheries buys bundles of twine for trap nets; the bundles cost about $8,000 to $10,000 each. It is not a simple matter of ordering the twine one day and receiving it the next. Even though they work through an American company in Memphis, it is necessary to place an order at least six months in advance and wait until a considerable number of additional orders are received before the Tennessee firm manufactures and ships the fisheries' request. Thus, ongoing repair at their own site is extremely essential to the Port Clinton business. For net repair and manufacture, this has always been the way, no matter what company is relied on or to what degree.

So elements operate that keep employees at work late into the night when the rest of the city sleeps. First, trucks arrive at all hours to transport tons of fresh fish to distribution centers throughout the country. People need to load the already boxed catch quickly onto semis so that this happens. Second, net repair, either anticipated or unanticipated, must go on. For example, a private yacht owner complains that he hit a net and damaged his propeller. Conversely, that hole in the net for Port Clinton Fisheries allows fish to escape, costs the company at least $250 for wasted fuel and negatively impacts the amount of anticipated delivery for the arriving commercial customer.

Granted, because of the expense and value, the nets are not all stored in the same building. Mr. Stinson remembered one incident when another business did this, to its peril. An angry employee set fire to the storage area, with a resulting total loss and demise of the company. Nevertheless, Port Clinton Fisheries is built for net repair, so many nets are stored on the second floor. Chains and pulleys hanging from the ceiling pull the nets tight a distance of about one hundred feet by fifty feet. Net repair, Mr. Stinson commented, is a dying art but one that, when practiced well, keeps an operation going successfully.

So in the long history of Port Clinton Fisheries, men have waited for arriving trucks and have worked at repairing nets. Even years afterward, the ghosts of people with well-respected Port Clinton names return to the second floor to labor on through the night. Chains clanging as they draw their nets tight, casually conversing as they go on about their routine tasks, the voices and noises of ghosts occupied in the work they love drift downstairs to living men as they go on, too, with the business that is in their blood.

"Once you are a commercial fisherman it never leaves your body," Mr. Stinson mused. "You can go anywhere in the world, do anything else you want, but that feeling never leaves. It's a part of you that is still with you." So it remains with you too after death. The ghosts return because they want to. They love their work. Why? Mr. Stinson sums it up better than I can: "It's my life. It's been good to me."

About the ghosts? The second floor, whether full of real-life activity or quiet, has a good feeling both for Mr. Stinson and for his guests. Another woman who serves in a variety of occupations, including photography and the ministry, accompanied me when I interviewed Lee. My friend Reverend Barb Cabral reflected on the positive energy emanating from the second floor, but when she started to take pictures, her battery died. It is an experience I am rather used to but an annoying one for those people who hope for photographs. Ghosts, because of their tremendous energy, drain batteries.

The Stinsons, the Lays, the Debiens, those long-respected Port Clinton names live and work at the occupation they love. Very much alive or returning from another world, the ghosts and people that have made Port Clinton Fisheries such a valuable part of the community continue their tasks at home, understood and very much appreciated. It is, as Lee knows so well, in their blood.

He Waits. He Watches

The Ottawa County Courthouse stands as a constant reminder to Oak Harbor residents—those economic, political and sports rivals of Port Clinton for as long as anyone cares to remember—that their village missed out on becoming the county seat. Less than fifteen minutes away, the village of Oak Harbor remains that—a village. For all its problems, Port Clinton has grown into a city that tourists enjoy in the summer; throughout the year, three major employers account for job opportunities: Magruder Hospital, Port Clinton City Schools and the Ottawa County Courthouse.

For a variety of reasons, when Port Clinton competed with Oak Harbor to be selected as the county seat, Oak Harbor lost. Occasionally, bad blood still flows between the two rivals—one a village of 2,500, the other a city of 6,500 or more—but generally most conflicts are friendly, the cause of the quarrel forgotten soon enough after the high school sports event…or the divorce.

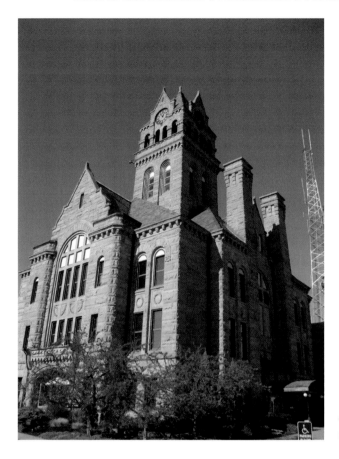

The Ottawa County Courthouse.

Actually, the current courthouse at the corner of Fourth Street and Jefferson, right across from the old middle school, is the third one on that same site since Ohio became a state in 1803. This magnificent structure built of sandstone quarried from Amherst in nearby Lorain County exemplifies Romanesque architecture at its grandest, including one of the hallmarks of Gothic designs as well: gargoyles. Guardians of buildings, four of these winged creatures perch at the corners of the clock tower. They deflect rain, true, but in their mythological way they protect the building from whatever lurks out there to cause harm.

Something else watches, too, a sort of nineteenth-century American version of Victor Hugo's Quasimodo, the Hunchback of Notre Dame. As with the poor grotesque creature of the novel, this figure calls the clock tower home. Peering out over the city to as far away as the Sandusky Bay Bridge, the figure waits, watching, hunched over with time and age. It can be seen

36

only from the east; from the west, nothing appears. Stand in the parking lot outside the jail. Gaze upward if you dare, at the clock face high above the courthouse lawn. Look between the Roman numerals IV and V. There, all night and early into the morning, a figure waits. He watches. With daylight, he is gone.

Those fearless ones who have climbed the several hundred steps to the top of the tower find nothing whatsoever that could cause that seeming shadow of a man. With the wind whistling and the bats circling, it is cold up there, and lonely. But with dusk, the figure returns to guard, along with the gargoyles, the city of Port Clinton and perhaps those rivals not so far away in the village of Oak Harbor.

THREE CHURCHES

In the western world, spirits are most active between the summer solstice (the first day of summer) and Halloween. There is no activity on November 1, All Saints Day. There is considerable activity on Christmas Eve, New Year's Eve and Holy Saturday. There is no activity on Easter Sunday. Not surprisingly, considerable ghostly or spirit activity occurs within churches. Consider that spirits return to places where they felt tremendous emotion: great happiness and great sadness. Weddings, funerals, baptisms and communions all take place in churches. With changing times and customs, these rites occur in other places as well, such as clubs, beaches, lighthouses and parks. How spirits react to the changes will be a pleasant study, but for now, let us discuss formal houses of worship only.

St. John Lutheran Church has long been an established part of Port Clinton. Magnificent Gothic architecture features beautiful stained-glass windows, some inscribed in the German language, which connects present to the past: Port Clinton founders of this church emigrated from what is now Germany. This is actually the third structure. The first was a frame church; the second, of brick, a place of worship from 1875 to 1913, became a beer distribution center. Today, a cornerstone placed at the present St. John location commemorates the founders' German ancestry. It reads, "St. Johannes Kirche." Only two blocks from the center of town, on Adams and Second Streets, St. John has seen its share of celebrations of life. It is not surprising, then, that a ghost comes and goes in this holy place. Several years ago, on the afternoon of Christmas Eve, the organist and a member of the choir had completed rehearsal for the evening services. No one else

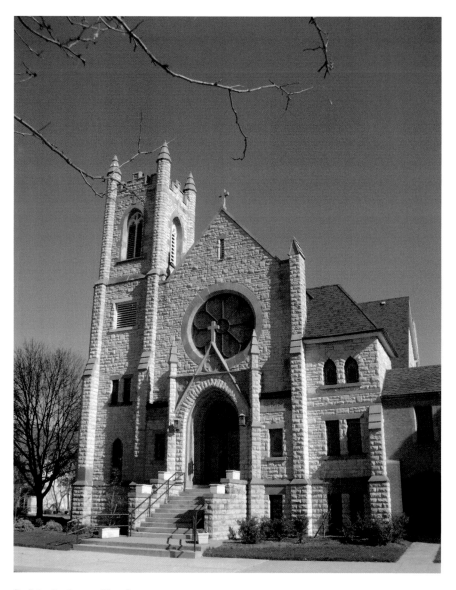

St. John Lutheran Church.

was in the building, which makes sense; people were too busy preparing for Christmas to celebrate any earlier than necessary.

It was late afternoon, shortly before twilight, a few days past the longest night of the year. As they turned off the lights and prepared to step out into the cold together, they heard, above them, a book drop. Both men

hurried up the steps to the choir loft in the second-floor balcony at the rear of the sanctuary. No one was there; but a hymnal most certainly had fallen, breaking the silence of that still place of worship on one of the most active days for spirits, Christmas Eve afternoon. At night, as ghost walkers gather at the corner by the entrance to the church, a streetlight blinks and then illuminates these searchers for manifestations of the spirits. Remember your Shakespeare? Flickering lights signify the presence of a ghost.

Other houses of worship contain their share of spirits as well. Trinity United Methodist Church, right across the street from St. John, stands as witness and survivor to an array of controversies, all eventually peacefully resolved. The building replaces a much older one razed in the 1960s. At the time when it was stylish to move to the suburbs, any number of the congregation argued to abandon the church and move to the edge of town. After horrific verbal battles, the resulting vote kept the newly planned structure on the original lot, at the corner of Second Street and Adams. A flickering overhead light at the entrance to the education wing reminds passersby that the ghost of Colonel Archie King, a loyal soldier in life, a longtime usher and a trustee at Trinity, keeps his beloved church safe from harm long after he has died. In February—a month he honored because of Four Chaplains Sunday, which commemorates two chaplains, a priest and a rabbi who sacrificed their lives for others during World War II—chimes from the bell tower ring out his favorite hymn, "Onward Christian Soldiers." Faithful even in death, Colonel King guards Trinity Methodist Church as loyally as he did in life. His wife, my mother, keeps watch too. The sanctuary lighting given in her memory not only illumines the darkness, but it also continues to shine on people, some of whom remember her only as the lady who sat in the pew toward the front. Although she died in 1998, on most Sundays her solitary seat remains empty. Out of respect? Or does she return to occupy her place, as regularly as she did in life, avoiding, as we human beings do, Sundays when she wasn't interested in the upcoming sermon?

One block to the west, St. Thomas Episcopal Church is reported to harbor spirits in the guildhall and in the sanctuary. Both places of joyous activities, it seems reasonable to expect that a few dedicated members of the congregation—and they usually are a small group that performs most of the tasks—return to help even in death. There is always a need for an extra hand to put on the craft show, another to flip pancakes and another to wash dishes. The spirits in all these churches and more are friendly and faithful if we just believe what we, Sunday after Sunday, profess that we do.

THE MARSHALL INN

Along with thousands of others who wished to escape compulsory military service in Prussia, young Frank Reichert immigrated sometime around the 1870s to Port Clinton, a young town itself, having been established less than forty years before. First a blacksmith and then a buggy maker, Frank married a beautiful widow from Toledo, Ohio, Elizabeth. Together Frank and his bride, a competent seamstress and entrepreneur in women's apparel, built their new home at the corner of Second Street and Monroe Street, one block south from the bustling downtown where peach and apple farmers brought their produce to market. Recorded in the Ottawa County Courthouse as erected in 1910, this large brick bungalow replaced an even older two-story white frame house, but it was far grander and finer than its predecessor and was certainly a symbol of the robust confidence of these two developers as they looked to the future.

And look they did. Frank never bought or sold property without consulting Elizabeth, who, though a fervent Christian, read Tarot cards as she advised

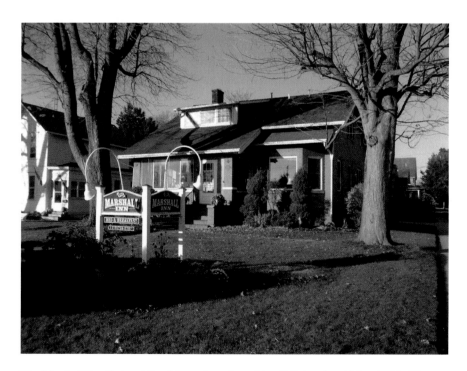

The Marshall Inn Bed and Breakfast, where the spirits of Colonel and Mrs. Archie King and Elizabeth and Frank Reichert still entertain and enchant guests.

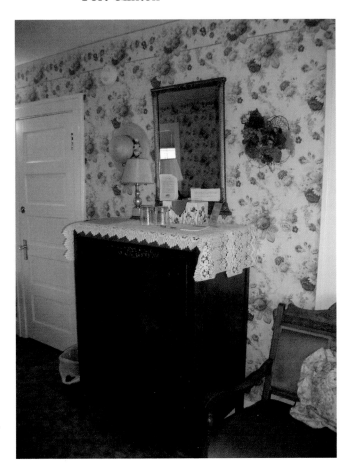

The Rose Bower in
the Marshall Inn.
Great-grandmother
Elizabeth Reichert
visits this room.

her husband about his investments. Their own home, at least five rental
houses and a vaudeville theatre that is now an insurance agency still stand
as monuments to the highest and best use of property as Elizabeth and
Frank envisioned over one hundred years ago. Exquisitely framed in walnut,
pictures of this prescient couple hang above the piano in the Marshall Inn,
which my husband Ed and I, the Reicherts' great-granddaughter, converted
to a bed-and-breakfast over a decade ago. Devoted to the end, my great-
grandparents died within a year of each other; Great-Grandfather in 1936
of a car accident and his wife in 1937 of heartbreak.

Caring and attentive to business, they loved their community, their home
and their family. It makes sense that even as they oversaw their property
when they were alive, surely they would return occasionally to check on
that same property even though they have departed. Don't we, if occasion

permits, drive by our former homes, wondering how the new owners are doing? What, for example, did they do with the windows, the paint, the landscaping? Are they happy? Do they love their home as much as we did?

Given Elizabeth's skills in the supernatural along with her well-known love for her home and family, it was a matter of time before the ghost of Great-Grandmother Reichert appeared both to me and to guests at the Marshall Inn. I first saw her near Halloween, that time when spirits are most active and most interested in this world. Elegantly attired in a black hat and black gown—widow's weeds as they were sometimes referred to during her era—Elizabeth peered around the corner from one of our guest rooms, the Rose Bower. As quickly as I saw her, she ducked back. But that is the way with ghosts; we see them out of the corner of our eye, quick, elusive. We wonder, first, did we see them at all. But we did, and just as suddenly as our consciousness confirms what we saw, the ghosts are gone.

My husband saw her that night too, although I certainly had not had time to tell him about my experience just a few minutes before his own. The family friends we had invited for a holiday dinner and tour of the inn arrived twenty minutes early. Frantic and not yet prepared, I opened the hall door to rush up the steps to the second floor for a cursory once-over of the guest rooms. I must have surprised Great-Grandmother as much as she surprised me, for she hastily slipped back into the Rose Bower. I ignored the momentary disquiet I felt from that summary glance, hurriedly requesting my husband give our friends the tour instead while I finished dinner preparations. Ghosts usually disappear when someone spots them, so I was as shocked as Ed when he returned, wide-eyed, to tell me that he had seen something at the top of the steps.

We know that business begets business; our inn, decorated that October with a Halloween tree, pumpkins and many other symbols of the season, called forth spirits from the ephemeral world to the concrete one. It was, that night, twilight, the time between two worlds when spirits are most active. So Great-Grandmother Reichert appeared, as well she should, not invited but certainly most welcome in her own home at a party sixty-two years after her death.

Since then, Elizabeth has manifested her presence in one form or another to guests of the inn. Interestingly, guests awaken in the late hours of the night to the scent of roses even though no roses are in the room. Somewhat haltingly, they ask in the morning if the Marshall Inn is haunted. So far, only women have witnessed my great-grandmother; some have actually seen a diaphanous form; others have breathed the sweet aroma of roses. But why the Rose Bower?

We named the room for the wallpaper we had chosen when we redecorated the bed-and-breakfast. We chose the pattern because we liked it, or so we thought. Great-Grandmother must have liked it too. She was, I failed to mention, a hat maker as well as a seamstress. Some of the accessories she used in her business were stored in the attic, just off her favorite room. The instruments, the accoutrements, the feathers, the flowers, the hatpins of her profession have long since been removed. But most likely, my great-grandmother is pleased with the changes and pleased, too, with retirement. One can only work so long, even in eternity. I doubt that her occasional presence is anything more than curiosity and a desire to help, if she can, with our business. She guided me to write this book—to start it, in fact, on the ten-year anniversary of when she first appeared.

COLONEL AND MRS. ARCHIE KING

Although clairvoyance passes down through the women in my family, it would seem that ghosts of both genders grace our inn. Those guests who see them may or may not be believers, but the believers have an easier time with the esoteric, as well as a more soothing experience. My father, Colonel Archie King, served in both the Marine Corps and the U.S. Army. As a young man, his experiences in one of the many Nicaraguan conflicts sometimes dubbed the Banana Wars shaped his life; he learned Spanish, which he applied to a career during the Cold War of the late 1950s and 1960s. During World War II, he served in the army, remaining in the reserve until his retirement. With Vietnam my father, a commissioned officer, also was a member of the local draft board.

Loyal to his country, my father suffered tremendous sadness over the nightly news depictions of flag burnings in antiwar riots. What he thought of the war he did not say. Years before, he had endorsed two men for officer candidate school; both were killed in Korea, and Dad never lost his remorse for the part he played in their lives. "Suppose," he wondered aloud, "I had not recommended them. They might still be alive today."

I keep his hat, decorated with the gold braid, leaves and emblem of a colonel, above a dining room china cabinet. A guest and veteran of Vietnam who noticed the hat with the "scrambled eggs," as soldiers call them, asked me about the story behind the owner. As I briefly recounted it, Glen sadly shook his head, reflecting on the many buddies he had lost in that war. "I still see some of them," he added. "They return to me in dreams."

We usually play CDs for background music while guests eat breakfast. Although our roles as innkeepers include serving food as well as polite conversation, we are sometimes hard pressed to juggle efficiency with relaxed conversation. His wife excused herself, the gentleman reminisced and I adopted an easy style of cleanup I did not feel. More guests would be checking in soon, and I had rooms to clean, beds to make. Another song floated from the living room CD player, but I paid no attention. Clearing plates, I pulled away from the guest as I hastily moved into the kitchen to glance at even more cleanup. It was then that I noticed my father standing in the doorway the way he used to do when coming in from outside. Daddy had died twenty-five years before, on October 22, 1982.

He smiled and then ducked back, out of sight. The conversation that interested him? The music that beckoned him? The song Louis Armstrong first recorded in 1968: "What a Wonderful World." Antiwar protesters latched onto that hallmark of the Vietnam era, twisting the meaning of the lyrics with pictures of their own. Yet the song remains, part of remembrances of the 1960s. The strains of music from forty years before reached out into somewhere, drawing Colonel Archie King back to the Marshall Inn to greet and comfort a daughter who misses him still and one courageous soldier who fought in a war many people would rather not remember.

Flickering lights signify the presence of a ghost. Shakespeare's audiences in the 1600s in England knew that as well as we do today. Recall, if you will, sitting stoically or dozing haphazardly through your high school English class as the teacher explained *Julius Caesar*, one of the Bard's most read if not most loved plays. American textbooks continue to include this gerry-built history that Shakespeare plucked from the Greek playwright Herodotus, and so, year after year, students are exposed to the Bard's views of Rome's last emperor before Augustus and the birth of Christ. A story of assassination, consequences, great heroes and terrible villains *Julius Caesar* remains good theatre if not an accurate rendering of history.

As with her colleagues, my mother, Dorothea King, faithfully waded through *Julius Caesar* with her sophomore classes at Port Clinton High School, where she taught English and headed the department Each year, she once again explained how Elizabethan audiences loved dramatic tales of history, revenge and violent ends, all enhanced by ghosts, gore and bloody conflicts onstage. In this particular play, the ghost of Julius Caesar appears to one of his assassins as a frightening precursor to foretell that man's death the following day. In one of the final scenes, Brutus, one of the many Roman senators who had joined the conspiracy to slay Caesar, opens a book. The

evening is dark and the time late as Brutus plans to read before going to sleep. A candle flickers; Brutus comments on it, and the audience knows that this means a ghost will appear.

So it does; the ghost of Julius Caesar, who eerily warns that he will see his assailant the following day at the Battle of Philippi. Brutus does indeed die, actually by suicide, but the dramatic manifestation of a spirit (actors were lowered either from the ceiling or raised from a space under the stage) beforehand blends the supernatural with the commonplace to create audience appeal.

It seems reasonable, then, that the ghost of Dorothea King, a teacher of history and English for well over twenty years, would choose to signal her presence at the Marshall Inn, her former home, by causing lights to flicker. Indeed, Mother's chair sat where the piano is now; an adjacent light still illumines the corner where she read. She died July 3, 1998, but her spirit remains at the inn, especially in the living room where she spent so many hours. When the overhead light blinks, and it does often enough, my husband and I greet her; we say hello, we thank her for being with us however briefly.

That, too, is the way with ghosts. I am not one to dwell on the reasons spirits return; they just do. Mother visits whenever she wishes; that, too, is the way of mothers and mothers-in-law. Pleasant, polite in life, Mother nevertheless was extremely curious. Of course she would pop back now and then in death. Why not? She misses her only child as much as I miss her; she loves her son-in-law. We wish her well; she moves on, as do we.

Spirits connect with this world through many mediums, their presence most salient, perhaps, through the five senses. The gifts of my husband's belief in the supernatural as well as those of the hundreds of guests who have blessed our inn provide a communication superhighway for which we are grateful. Separately and together, Ed and I have enjoyed the joyous concert of party noises drifting up to our bedroom from the basement. A farmer all his life, Ed is one with the land and nature, so to accrue life sounds from an esoteric world only broadens his enjoyment of this world. In fact, he usually does not mention his experiences except when they are particularly unusual. Because Ed is a night bird, while I fall asleep before the eleven o'clock news, he has the house along with the spiritual denizens to himself. He finally mentioned the continual sounds of laughter, music, pleasant conversation and accompanying clinking glasses that emanate from one room in the basement. That room, I informed him, was what Mother and Dad called the recreation room. It was, I continued, where their engagement party was held; thus the clinking glasses, the toasts, the laughter and, of

course, the radio music. My parents announced their engagement at the height of World War II. What we have almost dismissed for entertainment, the radio, was one of the few ways they could have had music at the party.

Psychologists affirm that among the five senses, that of smell is the strongest, most easily rekindling past memories or connecting us, however unexpectedly, to the supernatural. Early on a snowy January morning, I awoke to the aroma of freshly brewed coffee; my husband—previously sent, I am chagrined to confess, to the couch for snoring—announced that he smelled it too. Mildly annoyed with each other for brewing coffee at 3:00 a.m., we went back to sleep. At a more reasonable hour the next morning there was, of course, no coffee. Whatever spirit craved caffeine at an ungodly previous hour apparently drank its cup of java and floated on. As usual, the percolator stood ready on the kitchen counter; the coffee was handy; it seemed reasonable to take advantage of it. Evidently our guest list has expanded to include spirits as well as human beings. Innkeepers for over eleven years, we welcome them all. Hospitality is our business. I know for sure that Mother required, even demanded, her morning coffee. Daddy was a little more flexible, but he deferred to Mother often enough. Here's a toast to you all, be you Mother, Dad or someone else. Welcome to the Marshall Inn. Be our guest. Thank you for your visit.

SANTA CLAUS

December 1994. Sad, weary, I had returned alone that previous summer to Port Clinton, my hometown. At age forty-six, I was starting over. When once I had lived with my two children and my husband in a grand Victorian home in Marion, near Columbus, Ohio, now I rented a small two-bedroom bungalow back in the city where I had enjoyed a pleasant childhood. I had graduated with honors from Port Clinton High School; when I returned thirty years later people remembered, but so many others had since achieved far greater accomplishments. All I had ever really wanted was to be a wife and mother. That was gone.

My own mother lived two doors from me, as we say in the Midwest. At eighty-four, she was one tough cookie. My dad had died in 1982, so for twelve years Mother had effectively created a happy existence with her widowed friends. Now I returned, alone. We were two single women from markedly different generations; it's amazing we got along at all.

But we did, and Christmas was coming, a very different one from those we had celebrated with my family for so many years. Mother could be difficult; she had a right. So could I. I don't think I had that right, but I was indeed grieving.

Port Clinton had and still does have a community Christmas celebration that takes place in the little park along Adams Street. On a designated evening, people gather with their children to sing carols, eat cookies and, most wonderful, to talk to Santa Claus. As was characteristic of her at times, Mother did not want to attend that night with me. Looking back, I can see why. She did not feel as good as she pretended. She loathed going out at night in the cold and dark, and that evening ice and snow made walking treacherous as well.

But I insisted, so she rode along, refusing, of course, to get out of the car when we arrived. "I'll stay here," she emphatically pronounced. "You can go join the group if you want." I resigned myself to another of Mother's moods, slammed my car door and stormed over to the group of folks trickling up to the middle of the park to wait for Santa.

He appeared, I remember, from nowhere. There he was in front of me, trudging over the ice and snow to the little kids and parents excitedly milling around, their feet freezing, hands in their pockets. My mother balked in my car, but my own sadness propelled me forward. I was a little kid again; Santa could grant my wish if I just asked.

I stopped him. "Santa," I cried. Tears rolled down my cheek. "Santa, could you wait? I have a wish."

He turned around to face me. "Vickie King," he softly replied, referring to me with my maiden name. "I haven't seen you in a long time."

I believe he was as moved as I. "Santa, Santa," I sobbed. "I'm so sad. Nothing is the same. Please help me."

"I will, Vickie. I will," he promised. Then he was gone, moving quickly to the crowd of kids with wishes different but still to them as big as mine.

Nearly twenty years stretch between that first sad Christmas and today. I remarried in 1995 to a man who made holidays happy again. My mother died in 1998. And somewhere along those years, time and forgiveness have brought peace and joy. Without my knowing exactly when or how, I somehow found the gifts Santa promised when he granted the wishes of my heart.

CATAWBA ISLAND
AND MON AMI

Beautiful Cindy Bolte, an Ohio State fan and graduate and Delta Gamma sorority sister, graciously allotted time and energy to drive me around the Catawba Island peninsula, where she had spent countless happy childhood days. Real estate is in her blood; Cindy is a third-generation realtor as well as a go-to broker at Bolte Real Estate. Together with her son Phillip, there is almost nothing they or their agents can't sell. So it stands to reason that what Cindy knows about Catawba, she knows, both cognitively and intuitively. She will tell you up front that many of her stories link legends with facts.

Some of the stories she recounted that January day as we rode through the Cliffs, a now gated community, scaffold from *Legends of Catawba* by Henry Prescott. Mr. Prescott, who may or may not have been a real person, collected histories and tales of the peninsula, collating them into a short little book of about seventy-five pages. Published in 1922, the book Cindy owns is one of only 520 copies; she keeps it in a safety deposit box, as well she should. Here, then, are some of the fascinating stories she told that day, with a nod to history and to Henry Prescott, whoever he was.

NABAGON

Nabagon was a young Ottawa Indian who prized valor and courage in battle above all else. Beloved among his tribe, Nabagon one day stood on a Catawba cliff overlooking Lake Erie. He must have been dreaming or reflecting as he watched two sturgeon playing out in the water. Suddenly, it seemed as if one of the fish stared directly at him, warning him to "Beware!" Almost immediately, Nabagon heard terrified pleas from nearby. A panther was crouched, ready to attack a little boy. With his tomahawk, Nabagon leaped across the cliff to an adjacent one. Pushing the imperiled child out of harm's way, the brave Ottawa plunged his weapon deep into the panther's chest, but not before the cat's deadly claws critically wounded him.

The little boy Nabagon had saved helped him back to his tribe, where for days prayers were sent to the Great Spirit for his recovery. But the Great

The profile of Nabagon, the courageous American Indian. It is said that as long as his profile remains intact, Catawba Island will be protected.

Spirit needed Nabagon in the afterlife to protect the American Indians so cruelly treated by vicious gods. Nabagon died.

Sometime thereafter, the face of the valiant brave who had saved the young child appeared on that cliff where the panther had lurked. As long as the Watcher, as some call that rugged profile, remains, protecting Catawba, the people will be safe.

Cindy's generation, which is mine as well, remembers the cliff we called Nabagon. But in the past decade, time and the weather finally caught up with that great rock. The face was no longer visible; a waterspout in 1972 hurtled huge chunks of limestone into the churning waters below. With the disappearance of the chiseled features, so, too, the promised protection vanished. On a pleasant Sunday afternoon, November 11, 2002, a tornado ripped through Port Clinton and then Catawba Island, shattering homes and lives.

Tornadoes do what they will. One home can be safe; the neighbor's may be destroyed. Interestingly, that Veteran's Day storm wrecked, for example, one family's house while their friends', right across the driveway, was untouched. Behind the modern, upscale ranch house of that protected property two American Indian mounds rise unobtrusively. A casual visitor most likely would not even notice them. In the past year or so, however, an albino deer has stopped at the mounds every evening at twilight. I offer this: the property owner, a hunter himself, values the blessing of the Great Spirit, for he, along with the many hunters I know, respects the land and the wildlife still so much a part of Catawba Island.

Legend says that the panther that killed Nabagon was actually another such embodiment of the Great Spirit. To this day, hunters—for even among the condos and the million-dollar homes there is still farmland and woods— occasionally report seeing a glimpse of a black panther stealthily and quietly stalking its prey.

THE TREE OF THE BLEEDING HEART

Another famous story involves the Tree of the Bleeding Heart. Kids from my generation, Cindy Bolte and Linda Huston Allison among them, who rode their bikes and played long into those summer nights of childhood know very well the tale behind this perennial tree. Within the Ottawa tribe, a couple very much in love were parted shortly after their marriage. War forced Ralgo, the husband, to join his men; his wife, Actomah, followed him

The Tree of the Bleeding Heart. The heart of Actomah, long since buried here, is said to keep the tree perpetually alive.

as long as she could and then camped on the north shore of Catawba to wait for her lover.

After many months, her heart heavy and sad, Actomah learned in a dream that her beloved husband had departed to the Land of Shadows, never to return. Actomah too wanted to die, but American Indians believed, as do we, that taking one's own life was wrong. However, her father visited her, his heart heavy as well. The Ottawa were losing the war; the only way to defeat the enemy was a human sacrifice. Actomah seized the opportunity to join her husband. She volunteered to be that sacrifice. As her father prepared to slay his daughter, Actomah prayed that her husband be given her heart in death as she had given it in life.

Legend says that instead, the beautiful Ottawa princess and her heart were buried at the foot of a tree growing where she had waited for her beloved. That tree, the Tree of the Bleeding Heart, still stands today. Cindy said, "I can't tell you the number of times I've seen that tree go down. But it always comes back! One time I returned from college for the summer and I swear that thing had grown ten feet since Christmas!"

CAVES AND PROHIBITION

Caves run underground in the Cliffs. They have been sealed off now by concrete, but Cindy and Linda remember running through them as kids. "It's a damn wonder," commented Cindy, "we never got stuck in one of them!" These caves were a wonderful place too for rumrunners to hide during Prohibition. Boats carrying booze left Middle Island, the first island in Canadian waters as you leave Catawba, to meet grateful traffickers at various locations along the north shore of Lake Erie. Should anything seem suspicious, those vigilant merchants quietly waited in the caves and shadows of the Cliffs.

It must have been exciting to accompany the boats in the dark of night as they ran to and from Canada. My own mother remembered one such journey, probably with a date who invited her along at the last minute. A waitress during college at the Island House in Port Clinton, Mother left when her shift was over to ride to Middle Island with her boyfriend of the time. Something went wrong—a light, men's voices across the water, something. Mother did as she was ordered, holding her breath in fear as she pressed herself into the bottom of the boat. They did not get caught, but fifty years later, she still shivered when telling the story. It was one thing to flirt with the law and quite another to be chased by officers with guns and not much reason to hold their fire.

Nearly one hundred years before, those very caves and cliffs had been the setting of another war, not on alcohol but against the British. During the War of 1812, General William Henry Harrison served with Commodore Perry to protect the Bass Islands and the territory from the British fleet. The Battle of Lake Erie on September 8, 1813, saw hours of fierce fighting, with cannonballs discharged from both sides, the purpose to set fire to ships and to maim and kill sailors. Marks from those cannonballs could still be seen in the 1960s; Linda's mother and dad used to round the kids up, jump into the boat and bring it around to check out the cannonball caves along shore.

Some people say that ghosts still wander Catawba Cliffs. The area was developed in the 1940s for families after World War II. Apparently, spirits and their like are felt mostly around Weyhe Road and several hundred yards in from Nabagon. Adults now, the kids who raced around long after dark in the 1960s were terrified of something or someone who chased them. It was, as they report, "always at night; it always whistled."

Those same kids heard that whistling in the caves as well. Whatever or whoever waited in the limestone caverns, the walls inscribed with prehistoric

drawings and indecipherable writings, may very well just be biding its time. And we who try too hard, or search too much, may be better off just driving through, respectful, careful but moving on just in case.

MON AMI

Sometime sooner or later, everyone goes to Mon Ami at 3845 East Wine Cellar Road, marking the entrance to the Catawba Peninsula. The majestic stone building houses an elegant restaurant, a large bar for dancing and socializing and a delightful gift shop for both the oenophile and the souvenir hunter. Companion brands of Mon Ami Firelands wines are known the world over. A separate wine-tasting bar allows both connoisseurs and the curious to sample before buying.

Given the wide range of delicious foods on the menu, along with gracious hospitality, it's no wonder people have been coming to Mon Ami for over fifty years. Besides, the recent remodeling and upgrades make sipping wine and listening to jazz on the patio on a summer Sunday just plain fun.

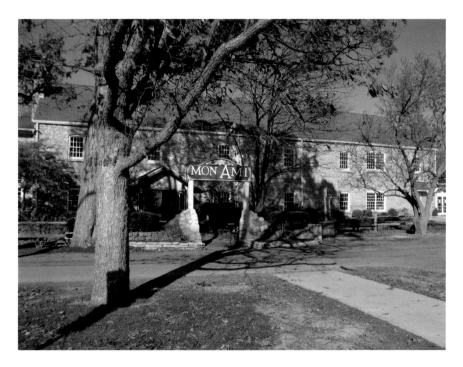

Historic Mon Ami restaurant and winery.

As a kid, I used to ride my bicycle down Sand Road to Mon Ami. There was something about it that lured me there; as an adult, I continue to enjoy the romantic ambience. Due to people's heightened fascination with ghosts during these recent years, it seems reasonable that stories would come to light about spirits at Mon Ami.

In its Halloween edition, October 31, 2009, a local Port Clinton paper, the *News Herald*, printed a few of the more interesting tales. Here they are, for your entertainment only. Whether they are true, I cannot say. What I can say is that this historic restaurant and winery is the place to be for a delicious meal and a good wine year-round.

Kristina Smith Horn reported in the paper that some employees hear voices down in the wine cellar, those voices from a ghost known as Malcolm. Legend holds, according to Smith Horn, that during the Civil War Confederate prisoners helped to build the structure, which was first a prison. Ghosts allegedly haunting Mon Ami are those of the prisoners who died here. Other employees have contributed tales such as seeing objects floating through the air and food randomly falling off shelves as if being pushed by some unknown force.

I have seen a few spirits myself at Mon Ami, but they come from a bottle, and I prudently let my husband drive me home.

PUT-IN-BAY

People the world over know Put-in-Bay, not so much for the history but more for the social nature of this village on the island of South Bass. Folks sixty and older may recall imbibing far more than their legal limit of adult beverages, missing the boat back to Port Clinton or Catawba and then sleeping things off in DeRivera Park. The less fortunate spent the night in jail. Since then, Put-in-Bay has deliberately placed limits on people's behaviors; those found fighting, carrying open containers outside bars and restaurants and sleeping in the park experience legal consequences as well as resulting headaches and nausea from the wine of choice, Pink Catawba.

Put-in-Bay remains a major tourist destination. Two boat lines service the island: the Jet Express from Port Clinton and Lorain and the Miller Ferry from Catawba. Depending on their urgency to get to the island as quickly as possible, eager passengers can choose the approximately fifteen-minute trip by catamaran from Port Clinton or the twenty- to twenty-five-minute ferryboat ride from Catawba. The Put-in-Bay airport also serves the island. Many summer residents fly in from the Columbus, Cleveland and Cincinnati areas, jump into the rundown cars they keep in the parking lot and head for relaxation to their retreat at the Bay.

When someone tells you they are "going to the Bay," expect tales—true or not—of romance—culminated or not—and wild exaggerations of the amount of alcohol they chose to enjoy. At any rate, a visit to Put-in-Bay during the day is more for families. But at night…watch out for more fun than anyone expected.

Perry's Victory and International Peace Memorial, built between 1912 and 1917. The monument commemorates not only Commodore Perry's victory in the War of 1812 but also, more importantly, the long peace between Canada, England and the United States.

There is far more, however, to Put-in-Bay than restaurants, bars and gift shops. Long before it was a village, Put-in-Bay was a harbor that gained historical significance because of the Battle of Lake Erie during the War of 1812. The following few paragraphs outline a condensed background. Most of the information was compiled from Gerald T. Altoff's scholarly book, *Oliver Hazard Perry and the Battle of Lake Erie*, published in 1999.

The United States was a very young country in 1812, less than thirty years old. Napoleon of France harassed Europe with battles and invasions. Great Britain suffered a blockade, courtesy of Napoleon, as well. Since shortly after the American Revolution ended with the Treaty of Paris in 1783, England refused to leave the United States alone. Great Britain captured American ships, impressing, or forcing, U.S. sailors to serve England's maritime fleet.

Native Americans in the Northwest Territories, which included Ohio and Michigan, saw the end of their way of life forever. Led by Tecumseh,

The Doctor's House,
now the location of
the EMS squad on
Put-in-Bay.

thousands of American Indians sided with the British, hoping that in so doing they could retain a hold on their land. The British, in turn, promised protection and food.

At the time of the War of 1812, Canada was a British colony. U.S. president James Madison was both disgusted by Great Britain's impressing American sailors and intrigued as well by the possibility of a successful U.S. invasion of Canada. The situation seemed right for a showdown between David and Goliath. America declared war on June 18, 1812.

Short of songs about the Battle of New Orleans, President Madison's wife Dolley saving the White House when Washington burned and the International Peace Memorial on South Bass, Americans' knowledge of the War of 1812 is summary at best. Oliver Hazard Perry's role in the Battle of Lake Erie did, indeed, turn the tide of war in favor of the United States, an extremely fortunate turn of events since up to that point the United States

had lost three significant battles and was in danger of becoming a British colony again.

At twenty-seven, Perry was a young man; he had married only two years before. In fact, other events in his career had so disappointed him that before the Battle of Lake Erie, he had requested a transfer from his command near Erie, Pennsylvania, where he oversaw the building of a fleet to secure the Great Lakes from British maritime interests.

Later that year, fleet completed, Perry led his ships to Put-in-Bay. From there he moved north to successfully blockade the British at Fort Detroit, now Detroit, Michigan. Ensuing dwindling supplies caused considerable worry for the British, whose promise of food and goods to the fourteen thousand Native Americans in the area secured their loyalty. It was time for the British, under the command of Robert Barclay, to confront Oliver Hazard Perry.

On September 10, 1813, Perry sailed on his flagship, the *Lawrence*. Included in his fleet were the *Niagara* and the *Caledonia*, as well as other smaller ships. Remember, these were sailing ships; no engines powered the vessels. Wind from the wrong direction could determine the outcome of the battle. At 10:00 a.m., the wind favored Perry. The battle lasted three hours; the Americans won.

Almost two hundred years later, with our sophisticated missiles and our ongoing vigilance of rogue countries with their capabilities for nuclear war, we find it difficult to empathize with the horror sailors experienced in that brief Battle of Lake Erie. But consider this. Altoff reminds us that guns fired cannonballs onto ships constructed almost entirely of wood. Wood splinters; gunpowder causes fires. Furthermore, the light breeze on September 10 meant that much of the engagement would occur as hand-to-hand combat on burning ships among sailors who, Altoff tells us, generally could not swim. It was, in fact, a recipe for terror straight from hell.

North Coast residents know the rest of the story. With the *Lawrence*, hopelessly crippled by volley after volley of cannonballs, Perry was forced to transfer command of that ship to other officers. He then took a small boat to the *Niagara*, where he continued to direct the fighting. The battle continued. One by one the British fleet, ships aflame, sailors mortally wounded, lowered their flags in surrender. Perry wrote a brief message to his colleague on land, General William Henry Harrison: "We have met the enemy and they are ours."

Shortly thereafter, Perry fought a few miles north in Canada at the Battle of the Thames, where Tecumseh died, he who had gallantly and almost successfully brought about American Indian victory over his white

enemies. The Battle of New Orleans followed, bringing Andrew Jackson fame and a following U.S. presidency. For Ohio and Put-in-Bay, however, the war was over.

Altoff discusses a disturbing occurrence, necessary at the time in war at sea, which may account in part for the ruthlessly malevolent forces in the Lake Erie Triangle and on Put-in-Bay. In the terrible heat of conflict, with the bodies of sailors splayed and bloodied on deck, efficiency demanded that these bodies be removed both because of the carnage and because they blocked access to battle stations. Without ceremony or thought, sailors threw the bodies of their comrades and friends over the ship railings into the lake. Do these ghosts, who never received a proper burial or recognition of any kind, return seeking justice and possibly revenge?

Fast-forward, please, two hundred years. Perry's Victory and International Peace Memorial, designed as a stately Doric column, rises over 350 feet above South Bass Island. On a clear day, it is easy to spot both the monument and the island from the Canadian shore and from the North Coast. Fanny packs around their hips, tourists clad in shorts ride the elevator to the top to look out over the peaceful international waters of Lake Erie.

How time changes things. No longer a naval harbor, today Put-in-Bay hosts 2,500 to 3,000 summer residents and about 500 year-round residents on an island three miles long and one mile at the widest point. Those who hunger and thirst for food and beverage can refresh themselves at many now famous establishments, including Tippers, the Beer Barrel, the Round House, Frosty's and the Boardwalk. In the summer, Pat Dailey's Irish tenor and inborn talent grace the Longest Bar in the World. Everyone knows if you haven't heard Pat sing, you haven't been to Put-in-Bay.

But the village has a serious side as well. A long-established school currently boasts eighty-eight students in prekindergarten through grade twelve. There is a newspaper, the *Put-in-Bay Gazette*, which carries stories of political interest as well as reminding visitors and residents of upcoming reasons to celebrate. Christmas in July, Halloween and New Year's Eve at the Bay (celebrated in September) draw thousands of enthusiastic visitors from all over Ohio, thus making a major financial impact on an island that can expect only six months of business.

Sometimes, however, things go awry for the very people who come to Put-in-Bay to enjoy a quality of life they cannot find on the mainland. Valerie and her fiancé, Bruce Metler, had for years promised themselves that they would spend the rest of their lives on the island that they loved. All they had to do was figure out a way. Both had enjoyed successful, fulfilling careers

in the emergency medical field and in law enforcement. Together, they purchased a home on South Bass in 1977, married hurriedly on November 5 and officially established what was badly needed at the Bay: an emergency medical station.

Shortly after they purchased the building, actually known as the Doctor's House after the physician who had lived and died there, a presence, most likely that of the doctor, made its existence known. In the front bedroom every night at 1:00 a.m., water ran in the bathroom sink. One evening a visitor staying in an apartment above the EMS station got up and checked; yes, indeed, the sink was wet. Someone or something sedulously washed their hands precisely at that time. A doctor perhaps?

For five years, Val and Bruce Metler lived their dream. By establishing their EMS business, they had found a way to move to Put-in-Bay and never leave. Then on December 9, 1983, Val as the dispatcher received a distress call from Kelleys Island, a few miles away. The mayor had had a heart attack and needed transportation by plane to Magruder Hospital in Port Clinton. Valerie hoped her husband would select someone else to pilot the aircraft, but Bruce was dedicated to carrying out the duty he and his wife had promised each other they would. Four men—Bob Rigoni; a township trustee, Duane Dress; Michael Sweeney; and the pilot, Bruce Metler—lifted off in patchy ground-to-ceiling fog. They radioed back that there was a clearing over Kelleys. Then, nothing. Val waited and waited. These four courageous men never made it. Their plane crashed, killing all of them. Another plane took the patient to Magruder, where he was treated and lived.

Two events surrounding this tragedy remain a mystery. First, Valerie never heard from her husband night. But the heart attack victim sent word back to the EMS station: he was so very impressed and grateful for the four men who had been there and saved his life. Those four men were already dead. They just didn't know it. Second, the area where their plane crashed is in the Lake Erie Triangle. One wonders if these courageous, strong, intelligent men confronted invincible forces even they had no hope of defeating: the souls of sailors lost in the Battle of Lake Erie and the magnetic hostile powers of the Lake Erie Triangle.

Over twenty-five years have passed, but Valerie recounts how her beloved husband still returns to her on occasion. For a very long time, she mentioned, he did not know he was dead. His comments reflected his confusion when, after years of being alone, Valerie began dating. Bruce appeared to her, wondering rather vaguely why she would spend time in the company of another man. She explained patiently to the ghost of her husband; it was

time for her to move on with her life. As the kind and caring man he had always been, Bruce's spirit wished her well, agreeing it was good for her to get on with things. Bruce returns from time to time. His wife knows he is around because he gently presses her right shoulder, sending a mild pleasant feeling down her spine and up into her head. He still talks to her, as she does him. His last words that tragic December night were these: "Don't worry. I'll take care of everything." And so he has.

Although Bruce still visits Valerie in the rambling Victorian home on Put-in-Bay that she loves, he is not the only spirit she welcomes. At one point in the mid-1920s, workmen lived there; Valerie hears their gruff conversations, the clatter of their boots in the hallway. In fact, a widow still, Valerie fears that the many ephemeral beings, both men and women, might move out at any time. "I hope they don't," she says. "I would be so lonely."

Her dog, Achilles, sees ghosts in the 1910 house, too. Most of the ghosts seem to like the entry hall and the front parlor. Achilles, a Doberman, is the kind of dog born with a herding instinct, so Val watches in fascination as he moves ghosts from various areas of the house into the parlor so he can put everybody—in this case everything—in the same room. He is, Val smiles, just doing the job he was meant to do.

Among the ghosts who frequent her home, Valerie and her friends have frequently enjoyed the Lady in White. Beautiful, attired in a flowing diaphanous gown, the ghost is probably, Val believes, the woman who originally lived in the house. Val likes her. She feels good around her. In fact, once when her daughter was visiting, Valerie was preparing pasta for dinner. The Lady in White appeared in the kitchen. In the rush to put the meal on the table, Valerie didn't pay attention to the presence except to assume it was her daughter. "Would you stir that pasta?" she asked the Lady in White. Val realized rather quickly that the unexpected guest would not be dining with them, just visiting for a while.

Apparently the Lady in White feels very much at home and curious enough to partake in the numerous activities of the household. One time, Val bumped into her in the hall. This curious visitor was sorting through papers and reading her mail! On another occasion, Val's girlfriend had spent the night at her home, where she slept on a sofa in the living room. Evidently interested in the guest, the Lady in White paid a visit. It was early in the morning; Val's girlfriend saw her out of the corner of her eye, which is the way most people see ghosts. "That's a beautiful gown," the friend commented, thinking that the spirit was a real person. The lady must have been pleased; most of us girls are when someone compliments us.

Then, for no apparent reason, the ghosts at Valerie Metler's disappeared for a few years. They have since returned to her most welcoming house. Valerie enjoys the company. I suppose, too, that her bloodlines facilitate paranormal visits. Her great-grandmother, she explains, was a practicing witch in Germany.

Her grandmother also had something of an influence on Valerie's life. Val cherished a white Bible that she kept near her for years. Although her grandmother had already died, Val wonders if she had something to do with the disappearance of the Bible shortly before Valerie's wedding to Ed, a man her grandmother did not like. The marriage ended, and Val later met Bruce, the love of her life. Curiously, that white Bible that she had given up hope of ever finding reappeared right before her new marriage.

Put-in-Bay and the larger South Bass Island, replete with ghosts, have been home to families extending back many generations. Vintners prefer the cool breezes and the surrounding lake, which extends the grape-growing season. Actually, there are three Bass Islands: Middle and North Bass as well as South Bass, all of them involved to some extent in the business of wine.

Lonz's Winery, built in 1934 on Middle Bass, saw its share of tanned faces turned pallid, but in almost all cases too much wine can be blamed for causing those out-of-body experiences precluded by headaches and nausea. From the 1960s through 2000, a summer day on the islands, particularly on the weekend, quite often involved visitors hopping onto small water taxis from docks on Put-in-Bay to take the five-minute trip to the winery. All this came to an end July 1, 2000, when a terrace at Lonz's collapsed. People fell; some suffered mortal injuries. The significance of the date and the year, 2000, cause one to wonder. Was this yet another manifestation of the power of the Lake Erie Triangle? Or was this a prelude of worse things to come? Patriot's Day.

Ghosts of all kinds frequent the islands. Lovers parted years before on earth return to Put-in-Bay, where their romance lives even though they too have died. About the middle of the twentieth century, when men still wore fedoras and couples experienced the pleasures of cigarette smoking after certain occasions, Marie and Bill fell in love. Whenever they were apart, which wasn't often, they practiced a little ritual. At the same time each day, they lit a cigarette. The sharp scent of the smoke, the pleasant inhaling of that first breath of rich tobacco filling the lungs drew them together in spirit even though miles separated them. For whatever reason now lost to time, they never married. Bill died of tuberculosis; Marie moved to Cleveland, where she became a secretary. She remained single. Years later, when Marie returned to Put-in-Bay, Bill returned too. Wearing a brown plaid shirt, a

fedora on his lap, Bill's ghost sat politely in her home as he visited Marie, the scent of cigarette smoke curling upward and gone, reminding her yet again that he loved her still.

A number of caves exist on South Bass. Some are open to tourists; some remain private, but owners permit scientific explorations. It was in one of these caves that a woman in the terminal stages of illness longed to visit so badly she prevailed on friends to take her along with a group exploration. Naturally, people took pictures. Those of the woman show countless orbs surrounding her. She died soon afterward.

Another story apparently well known to permanent residents of the Bay involves a fellow known as Black Sam Anderson. In 1898, a smallpox epidemic raged through northwest Ohio, affecting people on South Bass as well, particularly African Americans who worked at the Victory Hotel. Most likely they did not enjoy the same health precautions that their Caucasian counterparts received. Consequently, the disease exacted a greater toll among Sam and his peers. Sam died, but his ghost returned, appearing at the Put-in-Bay Lighthouse close to the hotel. Whatever vengeance Sam sought, he exacted. In 1912, the lighthouse keeper, so horrified by the ghost of Black Sam, went insane.

I heard this particular story as I returned by ferryboat to the mainland. The gentleman who related it—call him Scott—a member of a long line of island residents, added that his grandfather had seen the ghost of Sam too. Not one to believe in spirits, Scott's grandfather changed his mind after a sighting or two. Still, Scott requested that I not include his real name. "Everybody on the island knows the story," he added. "It's the only real ghost story I've ever known. I grew up with it."

Other stories of ghosts and hauntings came to light as I visited the Bay, where I have enjoyed many hours of fun myself, most of which I remember. People mention paranormal occurrences at a downtown hotel and ghosts bothering residents in old houses now used as rental properties. One of the most intriguing tales also involves the Victory Hotel, its short glorious life of thirty years ending in deterioration and fire. Hollywood movie stars swam in its pool; other guests included world-renowned authors and athletes. But a fire of mysterious origin destroyed the fabulous hotel built almost entirely of wood. Who started the fire? What creatures watched, and from where?

Put-in-Bay and the Bass Islands keep their secrets well. A visitor is only a visitor. But spend a winter on the islands and you learn, you the curious, more than you want to know. Or perhaps you join with those who share the mysteries of life in seclusion when ice and fog are your friends…and possibly your enemies, too.

KELLEYS ISLAND AND THE LAKE ERIE TRIANGLE

M ost people are aware of the Bermuda Triangle in the western section of the Atlantic Ocean. If one were to draw boundaries on a map, the vertices of Miami, Puerto Rico and Bermuda form a nearly equilateral triangle with the legs extending through or encompassing the Bahamas, Turks and Caicos and the island Shakespeare brought to the attention of his fascinated audiences with *The Tempest*: Bermuda.

In this, the shortest but most delightful of Shakespeare's plays, if the Bard truly is the author, we read one of the first references to the Bermuda Triangle. A British ship wrecked in the Bermudas earlier in the sixteenth century, thus bringing attention to these beautiful tropical islands, certainly fascinating to the English suffering from the chill winters of their homeland. In the play, Prospero (who is a king from Italy), his daughter Miranda and other relatives and friends are on a ship that is beset by a terrible storm or tempest. The ship is destroyed; the passengers find themselves on a remote island; we know it as Bermuda. Miranda exclaims over this magical place, committing a phrase forever to our Western culture: "Oh, Brave New World."

As with many documented occurrences in this triangle, Shakespeare's *Tempest* involves a sudden fierce storm, lightning and the paranormal. Ariel, a rather mischievous romantic spirit, reveals to his master King Prospero that it was he who caused the storm and set the ship's mast on fire. All ends well for the shipwrecked passengers in this most delightful of romantic comedies, but all has not ended so well for other travelers in the real world.

True, although thousands of commercial, military and private ships and planes daily traverse these hundreds of nautical miles and suffer no ill effects, some do. For the interested reader fascinated with what is also called the Devil's Triangle, there is considerable evidence—some true, some dispelling rumors—of mysterious disappearances, a parallel universe and communication from unworldly beings. The fact remains: those people clearheaded enough to signal their location and their distress before they are gone forever report being trapped in sudden fog and seeming nothingness. A powerful magnetic field with no predictable behaviors is blamed for disabling the vessels and their passengers; where they go has yet to be discovered.

Lake Erie, too, keeps dark secrets. Of the five Great Lakes—Huron, Ontario, Michigan, Erie and Superior—mariners consider Lake Erie to be the most dangerous because it is the shallowest, with an average depth of 62 feet or 19 meters and 210 feet or 64 meters at its deepest. On a sunny day, sudden storms with violent waves have surprised and frightened both novice and experienced boaters who, if they reach land, report the terror they felt as they prayed for guidance to a safe harbor on shore. Only 241 miles long with a width ranging from 38 to 57 miles, Lake Erie touches New York, Pennsylvania, Ohio, Michigan and the Canadian province of Ontario. Several islands of considerable interest to tourists and vintners are located within these waters, but those islands are discussed in other chapters.

What remains a concern is the Lake Erie Triangle. Depending on the sailor or charter boat captain you talk to, the vertices seem to form a nearly equilateral triangle. It begins with Kelleys Island, extends 12.6 miles northwest to the Hen Islands, then southwest to West Sister and finally east for 16.8 miles to Kelleys Island again, about 105.84 square miles.

As with the Bermuda Triangle, throughout the years the numbers of drownings, plane crashes and wrecks have underscored the growing evidence of some supernatural force powerful enough to destroy those navigators and their passengers who traveled through these mysterious miles at the wrong time. I mention ill timing because the powerful force causing such doom spews random magnetic fields that seem to originate from the eastern end of Lake Ontario. Hugh Cochrane's 1980 book *Gateway to Oblivion: The Great Lakes Bermuda Triangle* identifies a much larger area that includes Niagara-on-the-Lake and Toronto. However, for our purposes, we refer to Mr. Cochrane's study but limit our discussion to the smaller area of Kelleys, the Hens and West Sister.

At any rate, the unpredictability of these powerful forces makes travel even more dangerous. Nonbelievers might comment truthfully that they

have fished or boated for many years in the area so described and nothing unseemly has happened to them. They are probably correct; compare the random evil of the magnetic forces to the behaviors of a truly wicked person. Charming, interesting, he or she may disguise their true nature from us forever. Or, one day without warning, the Mr. Hyde our friends have warned us about manifests its ugly murderous presence—too late, it may be, for us to escape.

Consider the following incidents, only a few of the many I could mention. They are listed at random, as randomly and fearsome as the events discussed. It was 1959. A graduate of Sandusky High School, Ellsworth Dietrich, piloted a plane carrying mail to the Bass Islands and Kelleys. People called it white fog back then. Whatever it was came up suddenly from nowhere, causing the plane to crash and killing an experienced pilot. In another of many incidents, on October 22, 2009, an empty boat was discovered near Middle Sister Island; the boater was presumed dead. On October 23, a local newspaper reported the boater, Gerry Geyer, forty-six, was found dead. Earlier that summer, six experienced boaters fishing in the same area suddenly lost their bearings. Their GPS system shut down, and their own feelings were those of confusion and otherworldly disorientation. Yet again, off Kelleys Island, less than five years ago, a small plane crashed shortly after takeoff; its pilot (a farmer) and his young son were killed. The cause of the crash remains unexplained.

Another story, closer to my heart and my own life, took place off Kelleys in 1985. The husband (we'll call him Anthony), his wife (whom we'll call Marie) and their two small children departed in the morning from their transient dock on the island to return to Catawba. The trip should have taken about fifteen minutes. An excellent navigator, Anthony Paisano would never have left had there been any indication of danger weather wise or mechanically. The sun shone in a brilliant blue sky. Two days before, the boat had just been checked by certified mechanics at the Catawba marina where the Paisanos docked, and it was given the OK for the trip. With Anthony at the wheel, Marie relaxed in the stern; the children crawled into the V berth of the thirty-two-foot Bertram to sleep. Just off shore, however, a sudden fog enveloped the yacht. Anthony was in a hurry to return to his work on the mainland; Marie was annoyed with the seeming length of what should have been a short trip back to their cottage and her job of unpacking from their weekend. Time passed; the engines purred; yet Marie and Anthony realized with deepening horror that they were going around in circles. They were, in short, going nowhere.

Anthony's normally tanned face turned white. Shouting back from the steering wheel, he called to Marie, "I don't know where we are!" He, who at thirty-eight had navigated these waters for twenty years, had completely lost his bearings. Worse yet, the electrical system was down; the compass did not work. Such is the power of the Lake Erie Triangle when those unpredictable magnetic forces are unleashed.

Fortunately for the Paisanos, Anthony wrested control of the boat, bringing the family safely to their dock on Catawba. But instead of the fifteen minutes they planned on, it took two hours of circling and struggling in the gloom and enveloping fog to finally reach shore. Coincidentally, the name of the boat was the *Spectator*. Whatever sights Anthony or Marie witnessed that August morning in 1985 they have kept to themselves. The children slept through everything. And the boat? Domestic problems ensued for the couple shortly afterward. The boat was sold and the name changed.

MARBLEHEAD, DANBURY TOWNSHIP, THE VICTORIAN INN AND THE SURF MOTEL

MARBLEHEAD AND DANBURY TOWNSHIP

Marblehead, Norwalk. Do those names sound familiar? They did to homesick soldiers and settlers and those who followed them who received land instead of money as payment for services to the American Revolution. Part of the larger area known as the Firelands, this land, approximately 500,000 acres, was given by the new United States government to Connecticut citizens who had lost property as a result of the Revolutionary War. Why Connecticut? After the war, the state sold this territory to the federal government in order to finance establishing schools and colleges for their children. During that long war from 1775 to 1781, with the Treaty of Paris in 1783 officially ending the conflict between one of the greatest nations in the world and a group of rebels, British soldiers burned thousands of acres, particularly in what is now Connecticut. Thus, the property awarded either as payment or part of a settlement to people from the original eastern colonies became known as the Firelands. Marblehead, Norwalk, Danbury…these names, among others, reflect the background and former hometowns of settlers in the Ohio Country.

But after the Revolution, immediate peace did not come to the Northwest Territories and the smaller region now known as Lake Erie's North Coast. The Ohio Indian Wars from 1790 to 1794 brought massacres of both white settlers and Native Americans. And despite the Treaty of Paris, the British remained bitter over losing so much valuable land rich in fur, fishing and

potential farm country. It took many years and another war with England before peace of sorts eventually came. After Commodore Perry defeated British ships at the Battle of Lake Erie off Put-in-Bay located less than eight miles to the north of Marblehead, settlers finally felt comfortable enough to establish homes and farms in the Firelands.

Danbury Township to this day remains both a farming community as well as one rich in Ohio history. Two resort communities, Lakeside and Marblehead, also attract tourists who locate either seasonally or year-round for the fishing and the beauty that the peninsula, surrounded by Sandusky Bay to the south and Lake Erie on the north, offer. In the summer, tourists flock to a state park for camping and swimming; in the autumn, hunters still bring home game, descendants of those animals that roamed the region three hundred years before.

Although Marblehead's year-round residents number only two to three thousand, people from the Cleveland area and central Ohio cities continue to seek the peace and beauty that they find on vacations to the North Coast. Developers with an eye to opportunity have looked at what was once farmland and, before that, Native American domain and convinced themselves as well as others that condominiums and planned subdivisions represent the highest and best use of the land. That may or may not be so; change comes in many forms. People who fight it most fervently may be those who are the newest residents, the last to close the door. But other, far earlier residents have fought change too, with far more primitive weapons than newspaper articles, lawsuits and town meetings.

Danbury Township was home to Native Americans one thousand years before settlers cut down ancient trees to build cabins. At the turn of the new millennium, about 2001 or so, a developer energized by a particular section of the township insisted on new construction. Whether he and his partners adhered to all the legalities is rather uncertain, but they dug up more than they expected. They unearthed bones in a Native American burial ground. Construction stopped. Archaeologists, anthropologists, attorneys and expert witnesses from Native American tribes concurred that indeed these discoveries had been excavated from sacred ground. One of those witnesses, a medicine man, warned of impending disaster. Speaking privately to another witness whose word and scientific background he respected, he continued, "Things will happen, but don't be afraid." The medicine man departed, but a chain of events followed, none of them pleasant for the developers.

First, minor problems ensued—actually problems the old medicine man had predicted. For example, with prescience he mentioned troubles with

electricity. Sure enough, doors mysteriously opened that had been locked; any number of electrical situations caused construction delays. In fact, Amish people who had been hired for the job felt such evil surrounding the project that they left.

Eventually, construction continued. Then, in the late winter, when Lake Erie's damp chilling cold penetrates the bones of the living, one of the developers was found unexpectedly dead. A skeptic could conclude that the furor over the burial ground and the gentleman's subsequent demise were coincidental. A believer might view things very differently. Did Native American ghosts return to take justifiable revenge on people who had destroyed first their way of life and then, more cruelly, their final resting place? The developer may have an answer, but he too is buried.

EAST HARBOR STATE PARK

A township treasure, East Harbor State Park off Route 163 holds a small, carefully maintained cemetery located now in the group camping area. Surrounded by a black wrought-iron fence, the Lockwoods repose, their tombstones dating back to the mid-1800s. As was tradition with family farms, Lydia and her husband, Paul, were buried on their land. The inscription for Lydia reads: "She hath done what she could." Together with most farmers in the area, the Lockwoods depended on the peach crop as their main source of revenue. However, in the 1900s, when a series of harsh winters and worse springs froze the blossoms and destroyed the prospects of crops, the family sold their property to the State of Ohio. One wonders if Lydia and Paul still keep a watchful eye over the land they cared for. Many decades have passed; many thousands of campers in all states of sobriety have walked in and slept in the areas the Lockwoods once owned. Yet no one has vandalized the graves; no one in the park has been seriously injured; no one has been murdered. Lydia, I believe, hath done and continues to do "what she could."

THE VICTORIAN INN

About half a mile from East Harbor State Park at 5622 East Harbor Road, the Victorian Inn Bed and Breakfast radiates the majesty of its original use, a nineteenth-century farmhouse. With acres of peaceful corn fields to the back and beautifully landscaped grounds, today seven guest rooms, a great

The Victorian Inn Bed and Breakfast in Marblehead.

room for dining and additional private quarters for the innkeepers provide visitors the comfort and rest they expect. But years ago, things were different in this former farmhouse. Whatever happened there lingers, not so much a thing to worry about, just really a presence, a reminder that ghosts or spirits can and do what they want, whenever they wish.

Between the 1800s—when it was first built—and 1995—when Ann and Wayne Duez, the current owners, bought the property—the Victorian Inn was for a number of years a nursing home. People died here, and for whatever reason, they return to visit, not as guests but as former residents evidently claiming their space.

By the time the Duezes purchased the inn, it had fallen into such disrepair that it took two years to clean out the trash and bring the building up to code. Whether this disturbed the ghostly inhabitants we do not know. What we have, however, are reports from guests and the Duezes that clearly establish the continual presence of paranormal activity.

Most of this occurs late at night but sometimes in the morning as well. Several years ago, a couple staying in one of the rooms awoke to three

old men lumbering across the floor. Their heads down, moaning and sad, they frightened the wife so terribly that she wanted to scream. But as in nightmares, she opened her mouth and no sound came out. This seems to be the first incident; the alarmed visitors, not surprisingly, have not returned. Incidentally, they were relatives or friends who, as we call them in the business, were nonpaying guests anyway.

On another occasion, two single women sought rest and a short vacation at the inn. At 2:30 a.m., in the darkness of the night, one of the pair awoke with a start from a deep sleep. At first she thought her friend was talking in her sleep because of the moaning sadness she heard in the room. But that was not all. Across the floor walked a lady attired in clothing from another earlier era. She carried a human head in her hands. At breakfast, when the sun shone into the Great Room, dispelling any gloom from the night before, innkeeper Ann Duez conversationally inquired of her female guests, "How did you sleep?" "Awful!" came the stilted reply. Ann, an excellent businessperson, no longer asks that question, at least not with a tableful of guests eager to listen.

An anniversary clock Ann and Wayne had received as a gift stands atop a television in that same Great Room. The music and the accompanying chimes have been turned off to avoid disturbing guests' conversation and sleep. However, the clock continues to be a treasured family possession. One Sunday morning, the Duezes and their relatives gathered to reminisce around the breakfast table. Talk went on and on over coffee and rolls. It was then that the anniversary clock chimed—communication, it would seem, from Ann's deceased loved ones. They, too, were present, if only in spirit.

Excellent hosts these fifteen years, Ann and Wayne enjoy returning guests who have become friends during their numerous visits. Innkeepers spend time with their guests, both because they enjoy them and because this extra attention is part of their job and part of the allure of bed-and-breakfasts. One evening over coffee and dessert, as the Duezes and their guests talked together in front of the fireplace in the Great Room, the conversation turned to ghost stories. Nothing special happened—that is, until after the guests retired. Ohio law requires emergency exit lights in case of fire. Alone in their room, two of the guests, Bob and his wife, were chatting about their pleasant evening. Suddenly, the emergency light came on. It's very hard to sleep with a light blazing, so Bob climbed on a chair and reached up to turn the exit sign off, but it blazed away despite his efforts. Tired but willing to put up with the nonsense, the couple finished watching the news, turned to go to sleep and the light went off by itself. Enough ghosts, they thought, for one night.

This time they were right. But their conversation earlier that evening and the flickering fire had invited guests—or, in this case ghosts. It seemed only natural that the invitation was accepted.

Ann and Wayne have awakened any number of times to the smell of coffee. "Good," recalls Ann, "my husband turned the coffee on." But, of course, there was no coffee, unless one considers the gourmet appeal of the Ephemeral Roast.

As previously noted, Ann's friends and family sometimes visit, generally staying in Room 5, what used to be the servants' quarters in the old farmhouse. On one occasion, both the husband and wife awoke late at night to noises from what sounded like a card game down the hall in Room 7. This is the same room in which the two female guests had stayed when one was terrified by the ghosts of old men floating across the floor. But along with Room 7, Room 3 offers its own surprises, pleasant or unpleasant. On another night, Ann's cousin Brent and his wife were occupying the room when the wife experienced the chill of the grave piercing right through her. It was such a horrible, cold feeling that the next morning the couple insisted that Room 3 be exorcised. These relatives, love them or leave them, have not returned to the Victorian Inn, at least to stay for the night.

As with many people who live with ghosts, the Duezes go on about their business, accepting and for the most part appreciating an effulgence that radiates their lives beyond the ordinary. Spirit guests are just another dimension of this charming bed-and-breakfast. Now, if the ghosts would just *pay* when they stay! Cold cash is most welcome.

THE SURF MOTEL

On the anniversary, November 10, of the sinking of the ship the *Edmund Fitzgerald* off Whitefish Point in Lake Superior, I met with Diane Roziak-Thompson and Dan Thompson, the owners of the Surf Motel. Summer brings a thriving tourist trade to this clean, efficiently appointed business at 230 Main Street, Marblehead. At the edge of the community, the motel is perfectly located on the shores of Lake Erie. All sorts of folks stay here, from families headed to Cedar Point, the amusement park a few minutes away, to those who just want to fish, boat or swim as they relax among the beauty and serenity that the Marblehead Peninsula offers.

However, another aura hovers within the Surf Motel as well. Guests don't seem to mind much; oh, they complain occasionally, but this is a prime

Marblehead, Danbury Township, the Victorian Inn and the Surf Motel

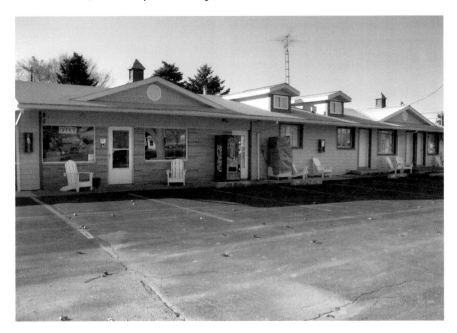

The Surf Motel in Marblehead.

location with excellent pricing and tremendous views, and they know it. What follows, however, is another aspect of the Surf Motel: residents, it seems, who neither pay nor depart—ghosts.

A document written by Marie Wonnell discusses the founding of Marblehead by the Clemons family, who emigrated from Portland, Maine, during the depression following the War of 1812. According to Wonnell, John Clemons and his son Alexander needed material to build their home on the peninsula. While excavating by hand, they continued to come across extensive deposits of limestone that, they realized upon research and reflection, would make excellent building materials and a fine business. In 1835, they shipped their first load of stone, and the quarrying industry was officially established. In fact, as Wonnell mentioned, the first lock at Sault St. Marie, where the *Edmund Fitzgerald* also traversed, contains limestone from Marblehead quarries.

Business attracts business. Other developers arrived to expand the booming mining industry. They dug more quarries and built kilns. The purpose of the kilns was to extract lime through a process that heated the stone to a very high temperature and then poured water over the product. Although both quarrying and kiln work were dangerous, thousands of people ignored the more sinister aspects in order to find employment during a depression.

A room in the Surf Motel where ghosts manifest their presence.

Many of them stayed, but many have disappeared forever, their whereabouts undocumented, unknown.

During those years, thousands of Italians looking for work, and most likely peace from the political turmoil in their own country, immigrated to Marblehead. They stayed in the boardinghouses that had quickly sprung up, among them one where the Surf Motel now stands. But quarrying was dangerous; one could fall so easily; the kilns, too, were a terrible place to die. What happened to those young men, so sure of their immortality, so positive that they would never be injured? Fewer than a dozen white tombstones mark the remains of those brave Italians who dreamed of saving enough from the mines to bring their families over soon, very soon. Where are the thousands of others? Did they return to Italy? Are their bones buried without ceremony or even acknowledgement under tons of rock and earth? Do their spirits roam the peninsula, asking for peace, for a blessing?

Perhaps answers wait in the Surf Motel. Several stories of salient or outstanding manifestations of ghosts may provide some explanation. On that bleak November day, as a cold northeast wind chilled us to the bone, Diane Roziak-Thompson and her husband, Dan Thompson, graciously accompanied me through three rooms where paranormal activities have been documented.

The most mysterious is Room 105. We know that unexplained cold signifies the presence of a ghost. Although the couple winterizes their

single-story motel, shutting off power, draining pipes and adding antifreeze, Dan keeps the heat on in Room 105. Yet, as we entered, cold engulfed us; Dan muttered annoyance at the pilot light in the wall heater that had gone out. Diane tried to turn the light on. "This switch never works right," she remarked as a matter of course.

The couple related how problems with Room 105 had begun in the spring of 2008. Hired to do spring cleaning, as is necessary for seasonal businesses, a woman brought her young son with her. Together, they stayed for a few weeks as she carried out her assignments. Mothers, of course, delight in taking pictures of their children; this lady was no exception. One night she snapped a photo of her son. What she discovered as she gazed in horror at the developed picture was a red orb in the corner and up to seventeen skeletal images in the background. Faces with darkened angry eyes and mouths pulled back into a grimace stared menacingly, not at the boy or his mother, but at anyone unfortunate enough to be in the room. I asked where the lady and her child were now. They have moved on, apparently, suffering no ill effects except for the experience itself.

However, I had the opportunity to look at the picture as well. There is a red orb, apparently a manifestation of something horrible, something waiting. I also viewed at least three deaths' heads, all apparently floating along the wall where the little boy sat. There may very well be an explanation for their presence. It is for one of two reasons.

The first could hearken back to guests of the original boardinghouse. Wonnell mentioned Mike Petronzio as an owner of the Surf Motel, off and on, until a final sale to the Thompson family in 1977. Called Metro Cake, the first gentleman worked as a foreman at one of the quarries and ran a boardinghouse for his fellow Italian laborers. The second Metro, a relative, continued to operate the business for a while.

Apparently, guests engaged in any number of entertainments, as one would expect considering their backbreaking labor and the ubiquitous hazards of their employment. Card games, women, alcohol and other recreations were an understandable outlet for those people who may or may not return the next day from the quarry. The story goes that in 1956 or 1957 during a card game, one of the players accused another of cheating. Shots were fired; someone in Room 105 died.

Dan Thompson commented that regardless of the outdoor temperatures in the fall, Room 105 is always the first to get cold and remain cold, even in the midst of Indian summer, that time when temperatures on Lake Erie's North Coast reach sixty to seventy degrees or more. Frost forms on

the windows; it's impossible to regulate heat in the room. A few years ago, Dan began his usual spring maintenance at the motel to prepare for the upcoming tourist season. Upon unlocking Room 105, he was aghast and, as a busy motel owner, overwhelmed with the spring routine, disgusted to see what looked like black paint haphazardly coating the walls. "It wasn't mold," he asserted. "It looked like someone had put black paint around and not finished the job." Angry ghosts? Ghosts from an earlier century when mourners draped their homes with black as signs of bereavement?

In fact, the Surf Motel has been a very active place for spirits since Dan purchased it, and most likely before that as well. Guests in Rooms 111 and 112 have reported hearing otherworldly voices and footsteps even though they were the only occupants in those rooms. Apparently children, who not only hear better than adults but also do not have the curtain of supposed maturity to separate them from the fantastic, clearly hear ghosts talking.

In 2002, two men stayed as guests at the Surf. Henry was said to be belligerent; not much is known about the other occupant, Jason. On June 3, 2002, Jason's body was found thirty-six hours after he was reported missing from a sailboat on which he was a passenger. The water in Lake Erie is still cold in June, particularly in deeper areas. What was recorded in the local newspaper is that Jason drowned while swimming around Middle Bass Island. Now, not many people swim off Middle Bass. Located a few miles from Kelleys Island, which is directly off Marblehead, Middle Bass in 2002 had a few homes, a small airport and a winery. The cause of Jason's death was attributed to drowning, but it is Jason who reportedly returns to the Surf Motel. Was he murdered? Did Henry so frighten or incite him that the young man chose escape in any fashion, including swimming? The coroner ruled his death accidental; Jason's voice in the Surf Motel seems to indicate something else.

The deteriorating remains of a limekiln a few hundred yards from the Surf rise as an almost Mayan monument to those long-ago quarry workers who died or disappeared from Marblehead. Most folks live with the stories or explain away strange occurrences, voices, lights or footsteps outside as the wind, kids playing or imaginations helped along by spirits of a more alcoholic kind. Nevertheless, the Surf Motel remains of considerable interest to investigators of paranormal activity.

Dan Thompson and his wife, Diane Roziak-Thompson, continue to graciously guide curious visitors and lodgers. Their motel is a business, and a good one. I suspect that this couple's friendly hospitality provides immunity for the spirits as they go about their daily routines. Spirits live among us; learning to live with them or around them is a gift.

JOHNSON'S ISLAND

During the American Civil War, which lasted from 1861 to 1865, Confederate prisoners occupied an island in Sandusky Bay, Johnson's Island. This was considered to be an excellent prison camp because of the surrounding water, which discouraged escape, but also because of the proximity of a city, Sandusky, where building materials and supplies could be obtained. Charles E. Frohman in his book *Rebels on Lake Erie* recounted well the brief history of the prison.

Some six months after the first shot was fired at Fort Sumter in 1861, the U.S. Federal government realized the necessity of establishing a prison camp for Confederate soldiers. The Lake Erie islands were considered for two reasons. First, the area was largely undefended. With Canada only fifteen miles away and Canadian interests in the South very apparent, defense of what is now the North Coast and the islands was crucial. Second, military troops stationed here could serve a dual purpose by guarding not only the shore but also Confederate prisoners. The eponymous Johnson's Island, so called because the United States government leased these three hundred acres for $500 annual rent from L.B. Johnson, was selected. For a number of reasons, the Bass Islands and Kelleys Island were not suitable; therefore, the small island in Sandusky Bay became the site of a prison camp for more than 2,600 Confederate soldiers.

Prisoners traveled by rail from the South to Columbus, Ohio, and then took a ferryboat from Sandusky to the island. Depending on the source, apparently life at the prison camp went rather well for some people. There

Above: Johnson's Island Cemetery, where Confederate soldiers are buried.

Left: Statue of *The Lookout*, said to patrol the cemetery, keeping the area safe from the enemy.

was mail service and a camp store. Prisoners were allowed to buy warm clothing, and several men even kept their servants. The guards played cards, formed musical groups and ate well, as did many of the prisoners, all things considered. Milk, coffee, bread, beef and onions were in rather good if not abundant supply, although fresh fruit for the prisoners was not permitted. Evidently, however, camp conditions were regularly filthy, resulting in a high incidence of illness and death. Typhoid fever, smallpox and diphtheria raged. Executions occurred, as did escapes, but these were few in number.

When the South officially surrendered at Appomattox in April 1865, the Johnson's Island prisoners were strongly urged to swear allegiance to the United States. Most did so. In the next few weeks, they were transported by boat back to Sandusky and eventually found their way home. By the following year, the Federal government broke down the camp, selling at auction everything from lumber used to build officers' quarters to stoves and harnesses.

Today, tourists and homeowners cross a bridge to the upscale homes on Johnson's Island, but at the end of the bridge a cemetery with the remains of Confederate soldiers reminds visitors and residents alike that a Civil War between Americans, not outside forces, almost destroyed our country.

Sally Sue Witten's book *Port Clinton, the Peninsula, and the Bass Islands* best discusses the history of the cemetery. In 1890, the citizens of Georgia replaced wooden grave markers with white marble tombstones commemorating the 206 men who died on Johnson's Island. A sign in the beautifully kept cemetery notes that 267 sets of remains are buried here; another source suggests over 300. In 1910, the United Daughters of the Confederacy dedicated a statue of a Confederate soldier. Known as *The Lookout*, he guards the entrance to the cemetery from Sandusky Bay. And with him, the stories of ghosts begin.

A sign aptly reads, "Dead, but...who still rule us from the dust." Most of the men imprisoned on Johnson's Island were members of the Masonic Temple. Even as prisoners, they held meetings and elected officers. Now, the Masons have their own ceremonies along with carefully held secrets. For prisoners to be allowed to meet in such a way, they needed guards. The guards, too, were required to be Masons. Legend holds that some of the prisoners were released to Sandusky to attend meetings there as well. When a Mason died in the prison camp, often his remains were shipped home. If the family could not afford to do so, the Masonic Temple to which the gentleman belonged was said to have paid for this.

As for the other men who rest eternally on Johnson's Island, a sign honors them, "in remembrance of the Masons who sleep here." Each year in the

spring, the Masonic Lodge conducts a memorial service in honor of those Confederate soldiers who came north and died.

But what of *The Lookout?* Does he truly keep watch? On the last weekend in April, a contingency of people from the South return to Johnson's Island to reenact the daily life and struggles in this former prisoner of war setting. They camp, they march and they carry out an official watch overnight. On many occasions, those faithful citizens remembering their heritage gaze with reverence and gratitude at *The Lookout,* who descends from his pedestal to silently march over the grounds. Shouldering his gun, dutifully pacing back and forth, he carries on, executing his duties as the loyal Confederate soldier he is.

A visit to this quiet cemetery brings a feeling unlike any other. One pays the toll to cross the bridge, gazes out over the waters of Sandusky Bay and, suddenly, there the white marble stones stand. It's easy enough to open the wrought-iron gate and walk in. But something envelops even the most respectful of visitors. A pervading aura of too many deaths and too much misery creeps into the mind and the spirit. A casual visitor quickly conjures up reasons to leave. Those more serious people who come to pay their respects linger not as long as they had planned; for them, too, it is time to go, time to let the dead bury the dead.

PORTAGE TOWNSHIP AND LOCKWOOD ROAD

Connecting Plasterbed Road to the east with Fulton Street to the west, Lockwood Road stretches about two miles along the southern section of Portage Township. Heteroscedasticity, a rather long term I bumped into in a real estate seminar I attended many years ago, best describes this interesting township abutting Port Clinton. Along the Sandusky Bay shoreline to the south and Lake Erie to the north, impressive contemporary homes appraised at half a million dollars or more tower over adjacent 1950s-era summer cottages. At the eastern end of Portage, Walmart, an upscale grocery store, gas stations, a scattering of chain motels and a furniture shop all identify themselves for advertising purposes with their wealthier sister township, Catawba. To the southeast and on into the center of the township, two factories built originally to process gypsum rock mined from local quarries operate, manufacturing building products for use all over the world. Within this same township, farmers harvest soybeans and winter wheat on the hundreds of acres still dedicated to and taxed as agricultural land. Deer, geese, ducks, groundhogs and even some mink and foxes find shelter and rest on the ponds and fertile acreage that hardworking people tied to the land for generations are proud to call their own. Children from these families and those in town routinely dine on venison their relatives and friends bring home after a day of hunting those same fields.

Of the many tales in this region of ghosts, spirits and unexplained forces, perhaps one of the more disturbing is that of Lockwood Road. What thing

lurks out there? What awful presence emanates from the rural peace of these fields and country homes? From his hideout among the cattails in the marsh, a ghost boy smirks at an unwary motorist heading east to make the turn from Lockwood onto Plasterbed. On a moonlit night if someone searches, he or she can catch a fleeting glimpse of his small white marble tombstone among the excrescence of weeds and vines there at the bus stop where a child is said to have been killed. Conflicting stories about the cause of the little boy's death include a truck hauling stone from the quarry or a school bus. Nevertheless, adults who as kids used to attend Portage Elementary School in Gypsum, where the boy was once a student, are familiar with his ghostly appearance there at the bend in the road where he used to wait. His name is lost to time.

An intrepid motorist, driving west, may encounter in the final half-mile stretch before the corner of Fulton and Lockwood one or more eerie sensations, escalating from a mild out-of-this-world feeling to a downright physical fight with an unseen presence. Realtors who regularly traverse the area, residents and simple passersby report what can best be described as a "Where am I, and what am I doing here?" feeling that dissipates when the driver reaches the relative safety of the overpass just beyond the intersection.

More frightening still, over the years numerous witnesses to terror have shuddered when reflecting on their experiences with an even more evil presence, one that grabs the steering wheel and tries with all its might to pull their vehicle into a ditch. Any number of people, from the newly licensed driver to the seasoned motorist, have recounted how, in those final lonely thousand yards or so, they have wrestled with an invisible power that tried to or succeeded in wrenching away control of the car. One such victim, a cab driver a few years ago, called her boss to inform her of the phenomenon. She and her passengers were safe, but she felt she needed to report how close they had come to an accident. Apparently well aware of this same malevolent force, the owner of the cab company acknowledged its power and then ended contact with the driver, perhaps out of concern for that same something that may creep along electronic equipment to manifest its presence in possibly a more terrible way. Through sheer determination, along with a very human concern for the fate of her passengers, the now former cabby managed to keep her van out of the ditch. Other motorists have not been so fortunate. Some lived to tell their stories; some have not.

In the 1970s, three farmers, good friends all, had gathered outside one of the men's barns to exchange views on just about everything, as farmers do. People who choose to live on and from the land share a fierce passion for

freedom and a great love of nature. They carry guns, they hunt, they care for their property and their neighbors and they see a lot more than townspeople think they do.

On a sunny summer afternoon, these three men, Mr. Johannsen among them, were taking an afternoon break from the hard work of farming. But as relaxed as they appeared, they kept a constant lookout on their fields and the road. A young couple they all knew well—call them Bill and Sue—who had just announced their engagement had stopped at the Johannsen farm that morning to pick out a puppy. The mother had delivered a litter of ten a few days earlier in one of the Johannsen trucks, and the delighted couple looked forward to starting their lives together with a new puppy too.

That afternoon as the farmers rested, they saw the couple's car going at least seventy-five miles an hour racing down Fulton Street past Lockwood Road toward Sandusky Bay. What happened next sickened them for days and years afterward. Bill, the driver, always drove fast; today was no different except for one thing: the puppy. He and his fiancée must have been distracted by their new pet, for suddenly the car careened and then lunged up an electric pole as high as the wires before completely overturning to land upside down in field. So terrible was the accident that both bodies were flung out of the car to their deaths. Only the puppy survived. Was it a young man's reckless driving or something else more sinister?

What scholars of Native American history know is that this section of Portage Township was a place to be avoided except for hunting, fishing and trapping. Wildlife abounded, but Native Americans came only to hunt, not to live. Did they sense that awful something that still lurks in the area, and did they know in ways that modern people do not that evil of such magnitude is best acknowledged and then avoided?

Terrible as these tales are, another story far sadder has surfaced only recently. During the winter of 2007, a farm couple, the husband a compassionate man and the wife with a soft heart for all animals, watched with growing wonder as two fawn born in the woods behind their house took to their wobbly legs and then, in the days following, delicately approached their backyard for treats the family offered. Winter ever so slowly turned to early spring; the fawns grew tamer, like family friends, if wild things can be that. But evil hunters had watched the fawns as well. Long after hunting season had passed, late one night when ice caked the sod where winter wheat slept, high school boys lay in wait for the deer. They slaughtered both for fun, leaving the animals to suffer in the cold before dying, the defiled bodies on display for the farm couple who had nurtured their pets.

But whatever happened that night turned inside out; at least one participant in the heinous crime suffered consequences he had never anticipated. Within a month or two after the slaughter, the leader of this band of cruel felons died by his own hand. A lifelong hunter, he turned his gun on himself. His friends and relatives in the next room were helpless to save him.

The force on Lockwood Road appears strongest within a half-mile range of the Fulton Street intersection, and with reason. Regional history provides some kind of explanation for such a fearsome power. Hundreds of years ago Ottawa County, particularly what is now Portage Township, was home to American Indians. Even today, farmers occasionally find arrowheads and spear points, jewelry, fragments of pipes and fire posts. Although no burial grounds lie along Lockwood Road, every bit as interesting is the fact that Fulton Street was first a well-traveled portage between Sandusky Bay and Lake Erie. When the Ohio country was still a frontier, still a vast expanse of wilderness, soldiers and French explorers landed on sandy beaches, unloaded their cargo and then carried or portaged their supplies and equipment along the three-mile stretch to Lake Erie, thus saving a trip of about eighteen miles by water around what are now the peninsulas of Marblehead and Catawba. Doing so also saved the better part of a day, thus enabling frontierspeople and soldiers, particularly during the French and Indian War, to travel up to Fort Detroit.

From the mid-1800s through the early part of the twentieth century, epidemics of cholera, diphtheria, smallpox and typhoid fever raged through the township as well as Ottawa County, closing schools and leaving devastated families behind. Although on the peripheries of the Great Black Swamp, existing marshes and low-lying regions in this part of Portage Township formed a perfect breeding ground for mosquitoes and whatever else lingered to cause suffering and misery.

How many deaths occurred along this trail, once a wilderness path? How many times did the enemy ambush and kill innocent parties? How many spirits roam out here in the rural fields and woods, anxious for release, for peace? Consider, too, that now in the second decade of the twenty-first century a hospital, a nursing home and many doctors' offices line the road where more than 250 years before injured dying people lay. Is this a coincidence, or has the universe in its unfathomable fashion brought healing where it is most needed?

For some of the spirits are kind as well. Muse, if you will, on this next story. My husband, Ed, has farmed all his life, as did his father, Bob. Cattle grazed in the fields, returning at night to their stalls in the red barn that still stands.

The Heinsens had chickens and were well known for their tomatoes, which they sold to a local canning company. Together with his father, Ed planted and harvested soybeans and winter wheat. The autumn of 1994, when Bob was diagnosed with a malignant brain tumor, he and his son had just finished planting winter wheat. Bob died on National Agriculture Day, March 22, 1995; that spring and summer, his son worked alone on the combine.

But it turns out he really was not alone. Farmers are well known for their workshops and their barns, which hold tools and parts from as far back as the 1800s, in case they might be needed for repairs. Many times they are! That first summer, Ed had returned to the shop from the field, searching, he recalled, for a part he remembered seeing. For no reason other than a feeling, he glanced up. There, standing in the doorway smiling, was his father, his best friend. As he was about to speak to the familiar presence he had loved and worked with all his life, Ed heard his mother call just outside. He turned and then, looking back, his father had disappeared. But just seeing his dad comforted my husband. He would go on farming, loving the land as his dad had for more than seventy-five years before.

Another story of great love and caring comes from this same area on Lockwood Road. In 1967, a newly married young farmer (John, we'll say), his wife pregnant with their first child, was in the barn greasing the combine to run it out into the field to work with his father. Always careful, he shut the combine off, but something turned the key to engage the engine. As he stood on the header, the combine moved forward. It would have pinned John against the barn, crushing him to death, but he had the presence of mind to grab an overhead beam as the machine rolled on.

To this day, John distinctly remembers seeing his life flash before him in a matter of seconds. Realizing he would certainly die, John did not feel bad for himself but only for those loved ones he would leave behind, most of all for his pregnant wife. Although he did not term this an out-of-body experience, he felt removed from his physical form as he looked back at himself struggling. But John's father, as with most farmers, didn't miss much. Observant, watchful, he wondered where his son was. Hearing the combine engine running, the older man ran to the barn, where he found John struggling against the oncoming force of a five-ton machine. Lunging onto the platform, John's dad reached the shut-off, stopping the combine. Then he verbally tore into John, as fathers do so well when they fear for their sons' safety.

Now over fifty years later, John looks back at an experience that changed his life. "I don't take it lightly," he reflects as his wife of thirty-four years serves him his favorite tea. "I know you can die, and I know you can be saved."

We do not know what lurks out there in Portage Township, just outside the city limits along those thousand or so yards where Lockwood Road and Fulton Street intersect. What we are certain of, however, is that over the years the malevolent force or whatever is out there has grown stronger, not weaker. Accidents that are not accidents, a senseless slaughter of two fawns, a suicide. These things seem to be manifestations of some vengeful spirit that those who are wise are best advised to avoid, if they can. Good spirits or evil, ghosts or demons, there is reason always to keep a cross in the car and to repeat the Lord's Prayer but more so when traveling, especially at night, down Lockwood Road.

BAY TOWNSHIP

If These Bones Could Talk

Bay Township remains mainly rural. Touched on the south by Sandusky Bay, with Lake Erie on the north, Bay Township offers a few resort developments: mobile home parks, a time share vacation spot with camping and condominiums and luxurious summer houses. But family farms dating back to the early 1800s spread throughout most of the township.

Crops such as soybeans, winter wheat and corn tempt wildlife and, it follows, hunters. In fact, venison that dine on soybeans taste like beef, great eating for Bay Township residents whose city counterparts may pay over twenty-five dollars for the same meal. In March, people in these parts anticipate great eating in what we call Muskrat Feeds at the township hall. Stacked on a fresh bun, drenched in special sauce with a side of French fries and coleslaw, nothing tastes better in the damp cold days of early spring than "some good rat."

However, long before hardy German farmers settled in the rich land of this part of northwest Ohio, Native Americans hunted, fished and trapped the region. As with what is now Portage Township, to the west and south of Port Clinton, the Iroquois, Ottawa and Chippewa came, but they did not stay. They built lodges, the remains of which you can still see if you are on the right property, far back from the roads. The lodges, though, were temporary shelters only. Native Americans sensed in Bay

Township what they felt a few miles away in Portage Township: something was not right.

Something in Bay Township is very, very wrong indeed. What might on the surface seem to be freak accidents, when one digs, shall we say, deeper, one finds a very evil presence that randomly attacks when and where it wants. Greg Johnson, we'll call him, has been excavating Native American sites for almost all of his sixty-plus years. His knowledge is so vast, his expertise is so renowned that archaeologists call him; his testimony and insights on legal matters are taken as fact.

What Greg encountered one dark day has stayed with him for over thirty years. Working alone on a farm along the Portage River, just off Route 163 near the village of Lacarne on what we will designate as the Patterson site, Greg was looking for artifacts: for example, cooking utensils, jewelry and hunting implements. He enjoys his work, as he did then, and was not paying much attention to how deep he had excavated, although he remembers looking upward to the ground far above his head. A tall, strong man, Greg is not one to be frightened off by anything.

But he was scared that day. For no reason at all other than that he did, he looked up out of what any of us would describe as a grave. The only way he can explain what he saw that awful dark day at the Patterson site employs a vague term that frightens us even though we smugly consider ourselves safe within our homes. A monster stared down at Greg that afternoon, a creature so hideous, so horrible that Greg still shudders remembering it over three decades later.

The site where he worked was also a burial ground. Greg had previously requested and received the appropriate approval to work there. Over the course of many months, he accumulated bones, carting them home, where he carefully catalogued each of them and then prepared to take them to the University of Toledo, which had enlisted his services. On one such evening in the 1970s, Greg's wife Tina, who usually supports all his work, demanded that Greg remove the bones from the house. "Put them in the garage!" she yelled at him.

Greg dutifully complied. Their daughters went to bed, but not for long. One of the girls awoke crying, "There's an Indian in my room, sitting on my bed!" Greg and Tina rushed to the little girl's room; both of them saw and felt the bed cave in as if someone were sitting on it. In another room, a lithograph crashed to the floor. Whatever presence emanated from the old bones made itself known, to the family's horror.

Thirty years later, Greg continues to excavate; Tina continues to support his endeavors. And their daughters? Both are well-adjusted, happy adults with lives of their own. But one, yes, one has been granted the gift of clairvoyance. We wonder, don't we, if some kind of good came out of those old bones after all.

NIGHT LIFE

Deer hunters take their sport seriously. They get up long before dawn to go out in cold rain and snow, hoping to kill a deer. Talk to any of them and they will most likely tell you of the buck or the doe they have been watching over the weeks. They know where it sleeps; they know the paths it takes through the fields and the woods. What they don't know is what the animal doesn't know either: when will it return to those same haunts?

David Richards (not his real name) placed a night-vision camera in the woods outside his cottage along the lake. Deer are nocturnal; he wanted

Deer in Bay Township with orb. *Courtesy of Fred Pachasa.*

to see just which deer traveled through and where they stopped. In the morning, David got an unanticipated surprise. Oh, he had his buck all right. And more.

An orb that looks more like a green spider web than anything else glows around the antlers. "It's creepy," David commented. Yes, it is. Venison is some of the best meat I have ever eaten, but, David, might I suggest letting that buck do just what he wants? David's neighbor Dr. Joe Darr put into words what longtime area residents know: "You can't swing a dead branch around your head without hitting something creepy in the Black Swamp."

Right you are, Dr. Darr. I think I'll stay in town tonight.

DAN'S DREAM GIRLS

Tall, handsome, dark-haired Dan Pachasa, in his late thirties, moves with the confidence and ease that come with being comfortable in your skin. He could easily be a paradigm for a romance novelist, but he is a living, breathing man who, over the years, has enchanted real women and, it naturally follows, unreal ones: ghosts. Recall, too, that much of northwest Ohio was once a part of the Black Swamp region.

Diphtheria, cholera, dysentery and other mosquito-borne diseases swept through the territory in the 1800s, killing Ohio's early settlers and American Indians alike. Today, grand resort houses and a cozy mobile home park spread out along Willow Beach and Balduf Road in developments built over reclaimed marsh that was once part of this Black Swamp region. Who lived there and who died before today's summer residents built their five-bedroom palaces or excitedly drove up to their new trailer on the lake? We don't know. But we do know that ghosts return to places they have loved too. And, as they have always done whatever the century, handsome young men continue to attract the attention of interested women, young or old, real or spirits.

It seems to be that way for Dan Pachasa. As a teenager, he enjoyed riding his Suzuki on the stone paths in the marshes between Willow Beach and Balduf Road. He must have been about thirteen or fourteen, he recalls, when one evening he was headed north back toward his family's cottage on the lake. Suddenly, a pretty young girl with long blonde hair and beautiful blue eyes appeared out of nowhere on the road directly in front of him. Flattered and interested, he turned his bike around to catch another glimpse of her. As suddenly as she had appeared, she was gone. For several minutes, he shined his headlight along the road and into the marsh as he searched for

her. But there was no one there. Nothing about the experience seemed right. It so disturbed Dan that for months he did not talk about it. The girl never appeared to him or to anyone else in this chatty, close community of friendly summer residents. But some twenty years later, he remembers her still, the will o' the wisp of Willow Beach.

Apparently the combination of a handsome man and the mystical atmosphere of Willow Beach attract not only young women but older ones as well. Some ten years after Dan's encounter with the beautiful young blonde, two "little old ladies," as he called them, evanesced in the same area. He recalls traveling that same road on a winter day about 1994. Along the side of the road, planting flowers, two older women worked with alacrity, cheerfully oblivious to the weather.

Dan neither invited nor enjoyed these two experiences, separated by a decade, in the home away from home where for all his life he has embraced an atmosphere of retreat. But we cannot always pick and choose our encounters with another world. I suspect Dan is rather accustomed to admirers. Decent fellow that he is, he politely but firmly moves away and on. The ladies of Willow Beach may have more in store for him. Knowing Dan, I believe he can handle it with a smile and a shrug of his shoulders. It's all a part of life…here or somewhere out there.

FRIENDS AND RELATIVES IN FREMONT

Spiegel Grove and the Rettigs

Drive southwest from Port Clinton about fifteen minutes to the county seat of Sandusky County, and you come to Fremont, Ohio, the home of the nineteenth president of the United States, Rutherford B. Hayes. Hayes's courageous service to his country during the Civil War is well documented; later, he honorably served our country as president from 1877 to 1881 before retiring to his beloved Spiegel Grove, where he and his wife, Lucy, lived until his death in 1893. Today, the Hayes Presidential Center is open to the public, the beautiful grounds and home well maintained as a nonprofit entity through funding from the family foundation and assistance from the State of Ohio.

An advocate of freedom for slaves, Hayes continued after the Civil War, throughout his tenure in the White House and into his retirement, to promote education and to defend individuals' rights. It was he who in 1879 signed a bill that permitted female attorneys to practice in the U.S. Supreme Court. He proposed to Lucy on the grounds at Ohio Wesleyan University; she was the first wife of a U.S. president to graduate from college. In fact, the Hayes website lists a number of other firsts. Among them, the Hayes administration was the first to install a telephone and a typewriter in the White House and the first to bring Washington children the annual Easter Egg Roll, the first Monday after the holiday.

The twenty-five acres of Spiegel Grove bear some discussion in our review of history and ghosts. *Spiegel* is the German word for mirror. Hayes's ancestor named his estate for the pools of rainwater that collected after a storm, mirroring the many oak and evergreen trees that majestically grace the grounds.

Mirror is an excellent term for this historic residence, for the city of Fremont and for the larger area as well. You see, the surrounding community has played a long role in Ohio history, beginning with the first residents, Native Americans. Seneca, Wyandotte and Ottawa tribes, all of whom contributed their names to the eponymous nearby counties, first hunted and settled here in the rich Ohio territory. Fort Stephenson was built as a resting place, almost an afterthought, for travelers and traders between Pittsburgh and Detroit. But with the War of 1812 and the impending British threat, Major George Croghan and a disturbingly small number of two hundred men at this same fort defended the area against British and American Indian attack. A walk through downtown Fremont may not place you within the walls of Fort Stephenson, but you will find yourself in an equally impressive edifice, the library, erected on the exact site where brave people helped turn the tide for America just two hundred years ago. In fact, when contractors built the library they stumbled across artifacts from the War of 1812.

During this same war Fremont, as it is now known, was attacked from the river as well from land. The story goes that a Native American woman and her white husband owned a little trading post along the Sandusky River where Whitaker Heights is today. They got wind of the impending British attack and warned Croghan. Croghan, of course, subsequently defeated the invaders, who retreated back down the river to Lake Erie. As a nasty thank-you, so to speak, to the couple who had warned the Americans, the British set fire to their trading post and then blew it up.

Mirrors reflect images, our own and those of others. Civil War reenactments at Spiegel Grove accurately mirror U.S. history, but other images have appeared as well. Memorial Hospital stands within a few hundred yards of the president's home; Timber Lane, a former residential street, is close by.

Recall that not only Port Clinton but also Fremont and other small villages and cities in this northwest part of Ohio played major roles in history, from the French and Indian War through the American Revolution and the War of 1812. Wars cost lives. We do not know what or who in other worlds reflects with sadness or vengeance upon the past. We do know that diverse images sometimes make their presence known, invited by real mirrors or reflected in other ways.

From 1978 to 1985, John and Fran Rettig lived with their two children in a pleasant ranch-style home on Timber Lane. Their son Chris displayed

a poster on the back of his bedroom door, something kids do. It can annoy parents to no end, as the tape and whatever else is used to attach decorations can permanently mar the wood finish. However, it was their son's room and not, they thought, a real problem. Until he became a teenager. You see, Chris always kept the door open, day or night.

One afternoon John, frustrated at his son's apparent cavalier attitude toward privacy, yelled, "Jesus Christ, you're a teenager now! Why don't you close the door to your room?"

Why not indeed? Chris removed the poster, revealing what had frightened him since he was a little boy. Deeply ingrained in the wood was the image of the devil complete with horns, teeth and an ugly twisted face. All those years Chris had held Satan back the best way he knew how: he relied on a little boy's ingenuity and simply covered up Satan. Apparently it worked.

But the devil had tried another venue much earlier as well. When Fran Rettig was a little girl, her parents owned a lovely table with a porcelain top. An image of Satan appeared here, too. The image frightened her and her brother so much that they refused to eat on that table.

Fran, of course, married John. They moved into the house on Timber Lane, and the devil followed. But, being practical Germans and churchgoing people, they ignored the sinister even when they learned about it; they went on with their routines. It is not particularly surprising that the career they successfully pursued most likely influenced their lives and those of others for the better more than they know. They were and are in the dry cleaning business. Cleanliness, as we know from Proverbs, is indeed next to Godliness. As they were protected, they have so protected others.

The Rettigs have stories of their own, about what they have cleaned and what they have kept quiet about concerning items they have found along the way. But we'll let John and Fran tell you those. It is not the purview of this book to iterate tales of skeletons in the closet or best-forgotten dainties in trouser pockets of someone, not necessarily a spouse.

AUNT MARTHA

For more than twenty years, Mary Swartzlander Hetrick has truly enjoyed her waterfront condominium on Sand Road in Catawba Township. She is, in fact, a Port Clinton resident. But she is very proud of her Fremont heritage and her Fremont friends and relatives. She told this story about

her Aunt Martha, whose insouciance to the implications of practical jokes bothers Mary somewhat but her aunt not at all.

In life, Aunt Martha was known in the family as witty and fond of playing harmless tricks on those she loved. Long since deceased, Aunt Martha continues her ways. A hardworking Polish immigrant, she came to Cleveland, where she worked and met her husband Paul. They moved to Southern California at the end of World War II, where they set up housekeeping and raised a family. Aunt Martha bustled about in life and is now just as busy in death. Any number of times Mary has *mislaid* important items only to have them turn up considerably later in some other place where she had already looked.

Mary and her sisters own a condominium together in Florida and share vacations there as schedules allow. Mary likes to tell this story about one of her beloved aunt's practical jokes. The weather that Port Clinton winter was horrible: ice, snow, freezing rain. Mary eagerly anticipated her well-earned rest in sunny Florida. Everything was packed and she was ready, except, unfortunately, for the keys to her retreat. Where were they? She looked in the car, she pulled cushions out from the couch; she crawled as far under the bed as she could, hunting for those keys. Organized and intelligent, Mary is not one to misplace anything, let alone her own keys to her queendom. Trudging across Sand Road to her neighbor's house who oversaw Mary's property in her absence, she looked there too. Nope. Those keys were gone.

Out of sheer weariness and major frustration, Mary gave up. Sometime later, her friend called. Mary crossed Sand Road again to welcome Erica back from her travels, and there, on the counter, were the keys to the condo. "Where did you find those?" a stupefied Mary asked her friend.

"They've been here all along," responded Erica calmly. "Why, have you been looking for them?"

Used to Aunt Martha's many tricks, Mary grinned in relief at yet another well-executed practical joke. "Yes, of course I have. I'm just glad they showed up."

But Aunt Martha's sense of humor stretches long with a beginning and well-timed end. Recently, Mary recounted another escapade as she talked with friends a few years after the Case of the Missing Keys. Around a dinner table at a friend's home after an early New Year's feast of pork, sauerkraut and mashed potatoes, a meal to bring good luck in the coming year, six people had relaxed into a camaraderie of good food and good wine. One of the guests, Mary among them, turned the conversation to ghost stories. Remember that spirits are quite active both on Christmas Eve and New Year's Eve.

Not only did the time of year more easily draw Aunt Martha back to remind a beloved niece of her joys in life and in that other world, but on that particular day, December 27, 2009, the full moon was only four days away. Four days on either side of a full moon smooth the path for spirits to glide back and forth if they choose from one plane to another. Mary's Aunt Martha story entertained dinner guests as they enjoyed a few final sips of wine before their hosts served dessert.

A certain quiet surrounded the comfortable company, warmed that winter afternoon by friendship and good food. Then, a sharp ring from the telephone shattered the silence. The host got up to answer. At the other end of the line, a voice with a heavy accent asked for Martha. Stunned, the dinner guests first thought their host Rick was kidding. But his sober face indicated the contrary.

Guests stared vacantly at one another and then forced a few laughs. Rick checked "all calls" both made and received on his phone. Nothing registered except the neighbors' number when they had called three hours earlier to inquire about the time of the party.

Ghosts have their own sense of humor, however wickedly funny it may or may not be. I neglected to add that Aunt Martha took advantage not only of the season but also of the most infrequent appearance of a blue moon: two full moons in one month. The last one had occurred nineteen years before, in 1990. Was it truly Aunt Martha calling once, as they say, in a blue moon?

ARI'S GHOST STORIES

Ari and Hedi Eickert immigrated to the United States from post–World War II Germany. Ari arrived first; Hedi followed after she graduated from the university where she majored in fashion design. They were married shortly afterward. As children, they remember those terrible days in their homeland when they did not have enough to eat and winters when they were very, very cold. With hard work in their adopted country, combined with their general pleasant outlook, life changed for them for the better.

Today, they entertain friends in their spacious home just outside of Fremont. On a pleasant summer day, those lucky enough to be invited aboard their delightful pontoon boat, the *Martini Barge*, enjoy a relaxing trip down the Sandusky River. Fond of martinis themselves, the Eickerts offer hospitality, intelligent conversation and a genuinely good time.

They value the arts as well, generously patronizing symphonies, operas and the museum. A musician of some renown, Ari cheerfully strums his guitar at occasional impromptu get-togethers on the beach as waves roll in off Lake Erie. Ari writes, too. He knows Sandusky County better than I do; he collected the following tales at my request. As he comments in his introduction, "All the stories of mysterious occurrences or apparitions I heard from people who heard it from people who may or may not have experienced them." The legends have been around for some time. It took a person familiar with the area to collect them. Thank you, Ari, for your research and your work. Here are his stories, some word for word, some slightly altered.

The Headless Motorcyclist

Near the village of Elmore, just across the Ottawa County line in Sandusky County, Fought Road crosses Mud Creek. At the close of World War I, a soldier returned to his home expecting, after enduring the horrors of battle, to live out his days with the girl he had left behind. Instead, he discovered that his true love had deceived him by having an affair with another man. Out of his mind with anger and hurt, the young man murdered the pair and then jumped on his motorcycle and took off. A light drizzle that night combined with the speed and the tears in his eyes as he blindly raced down Fought Road. His motorcycle sped out of control on the bridge; he wrecked his bike and died almost immediately. But the soldier's soul could not find peace. Restless and remorseful, it lingers around the bridge, searching for forgiveness. Legend has it that if one stands on this bridge at certain times in the evening, one might see a motorcycle tear across. The fortunate, or the curious, standing by the side of Fought Road may just see the sad soldier as well, racing toward a peace that he will never find.

The Severed Heads

In the 1960s, a carload of teenagers out joyriding stalled at the railroad crossing that runs along a golf course. No one knows whether the kids tried to cross the tracks or if the car stalled, which is easy to do if one is just learning to drive and has a stick shift, as was so often the case some fifty years ago. Perhaps the car doors jammed or the kids, screaming, just could not get out in time. As any attorney who has defended the railroad knows, it is impossible for a train to stop at short notice. The four teenagers died

instantly. But legend has it that if one drives to the crossing alone at midnight and stops by the tracks, one can catch a glimpse of the twisted metal remains of that car-turned–death wagon. And if one looks carefully, four severed heads stare back.

Crybaby Lane

Many years ago, a young mother abandoned her baby on a remote lane outside the village of Lindsey. Left to the elements and to hunger, the neglected baby eventually died. But people claim that if, during the dark of the night, one flashes his car lights three times, he can hear a baby cry.

Tindle Bridge

The area adjacent to the Tindle Bridge in Fremont was once a burial ground for American Indians. It is said that at one time so many corpses lay there that the ground itself felt like crusty snow. Hundreds of years and many generations have passed, yet the land itself seems to retain its haunted atmosphere. In the 1950s, a young woman was murdered there, her spirit so surprised by sudden death that it roams even today, sobbing and pleading for help. Recently, another murder victim was discovered in the very same field. Whatever lurks there is best to avoid; whatever wants revenge seems, perhaps, insatiable. So, as Ari wisely advises, "It might not be a good idea to cross the bridge alone during the night. Be careful!"

FINAL THOUGHTS

The Witching Hour

Popular myth confirmed as truth, through Hollywood's imprimatur or official approval, dictates midnight as the witching hour. People who care to open doors they soon realize to their regret they cannot close, those gateways into another world of things we invite only to our later misery—those people are free to explore the late deep hours of midnight and beyond.

However, there are far better times with happier results for true believers who wish to communicate with spirits: twilight. Each day offers two twilights, the first about an hour and a half before sunrise and the second an hour and a half after sunset. Photographers call this second twilight the blue hour or the golden hour; people look their best, women their most beautiful.

But twilight provides another occasion more appreciated for its ethereal aspect. This brief time between two worlds when there is no sun, when darkness and dusk are just beyond the horizon, is the part of day most favored by spirits. They prefer the otherworldly romance of flickering day and darkness.

Think back to your dreams. Most people who dream of their departed loved ones see them quite clearly in those minutes before waking: morning twilight. Knowing that, it is possible to plan before sleeping how to let a loved one know that you miss them as much as they miss you. If your loved

one has been particularly communicative through dreams, determine upon going to bed that not only will you talk with them but you will continue to be receptive to their visits as well. You love them still. Deliberately think of it; place a note on your nightstand. It can't hurt. See what happens.

Is there a place such as a garden, a park, a boat, a beach that your loved one enjoyed? If possible, go there at twilight. Begin a conversation as you used to when they were alive. Thank them for how they have made your life better. Be specific; be polite. Spend time with them. Isn't that really all our parents or our extended family wanted from us anyway—time? When you leave, say goodbye. Tell them when you plan to return. It's not so difficult. My friend Linda talks with her dad all the time even though he died fifteen years ago. She sees him in the wildlife he loved so much; she hears him in the songs of the birds, the chatter of the squirrels. They were a part of his life. Now they are a part of her life too, just in a different way.

Then go back to your real world of asphalt, concrete or fields. Let some days pass if possible. Then try again. No one promises that the spirit of the father or the grandparent you loved with all your heart will appear to you upon request. What I do suggest is to open yourself to ways that these people now gone will communicate with you. The entire universe awaits.

Did your mother delight in the song of a wren? Did your father laugh at blue jays? Listen again to the wren outside your window. Look again at the blue jay happily hopping from branch to branch in the lilac bush near your back door. Pay attention to the smell of roses, the scent of cigar smoke, the flickering light at the intersection on your way home. Are those departed people you love and miss letting you know that they miss you too? That they love you and are there for you? I believe with all my heart that they are close by, as near as our longings, if we just look…and listen.

ASK SAINT ANTHONY

My Catholic friends taught me a simple prayer for which I am most grateful. Many of my friends from other religions know it as well but need a refresher course to remind them that spirits, angels, loved ones now in heaven, saints and, of course, God remain as close as our prayers if only we ask and have faith. Only thirty-six when he died in the thirteenth century, Anthony of Padua was declared a saint less than a year later. He was such a devout and good man that he continues to this day to be revered. He is also known as the "finder of lost things." The following prayer works. Describe what you

have mislaid. Then say, "Tony, Tony, turn around. Something's lost that can't be found."

Look again for the article, be it money, car keys or anything else you have misplaced. Give yourself and Saint Anthony a little time to work. Trust and believe. When you find what you have lost, and you will, be sure to thank the saint. If it is money you have found, or a wallet, for example, make a contribution as soon as possible to a worthwhile person or group. If you do not offer thanks, don't bother to ask Saint Anthony again. You will not receive his assistance.

I am only repeating the instructions I was given. Because I have always followed them exactly as have other people I have guided, I can only relate what has happened to them and to me.

The items most frequently and annoyingly mislaid are car keys and wallets. About two years ago, a family friend stopped by to distribute material during an election year. An hour later he returned, distraught. He had lost his wallet along the way; had I perhaps seen it? A practicing Methodist, he was unfamiliar with the prayer of Saint Anthony. Together we prayed. I asked him to call me as soon as things worked out. That afternoon, the doorbell rang. A wide-eyed believer gratefully recounted how it occurred to him to check where he never expected to find his wallet. But, amazingly, it was there. I reminded him about the other part of the agreement as well. He assured me he had already taken care of that.

Amazingly, even people who are familiar with this small miracle occasionally require a strong spiritual elbow to the ribs to remind them how close the other world is and how much we can be helped, if only we ask. "I know, I know," my New York savvy friend Kay muttered when hurriedly hunting for her keys while visiting her parents in Port Clinton. "But I don't have time."

"Then let me say it if you won't," I insisted. Together we prayed. Within five minutes, she had located her keys. After that we managed to find drinks and dinner…and a few more drinks. It was my turn to buy; she drives me around more than enough in the Big Apple.

The list goes on and on of other people who have turned to Saint Anthony and been blessed. Now, you may or may not believe. But mark this page either way, just in case you need it.

REFLECTIONS

Thank you for reading these tales of adventure and ghostly appearances on Lake Erie's North Coast. Since I began this book in the fall of 2009, my former husband, Mike Piacentino, has died. You read about him as the courageous captain Anthony Paisano in the chapter called "Kelleys Island and the Lake Erie Triangle." It was a shock. His death came suddenly, a massive heart attack. My children, Rocco and Gina, and I will never be the same. My husband, Ed, has been wonderful, as have our many friends. I am glad that Mike and I were at peace these last few years. In fact, I had arranged a ghost walk especially for him over the past Labor Day weekend, but he was not able to make it. Interesting, isn't it. We all thought that there would be another time, another ghost walk.

I suspect the kids and I will see Mike again over the years. He certainly was a strong individual; he loved life and lived it to the fullest. In fact, in the days following his death so much of what he touched changed too. His laptop, for example, was suddenly infected with an unexplained virus, so much so that it was impossible to bring up his files.

But that is the way with ghosts. The electronic age has made it so much easier for them to communicate. And communicate they do, through televisions that turn off and on inexplicably, flickering lights, cell phones that ring when no number appears, music from the radio that plays…out of the blue.

Even after death, those we loved linger around the people they care about, trying still to protect them and to guide them. Their spirits return on birthdays, holidays, favorite days or the anniversary of their deaths. They have not forgotten us any more than we have forgotten them. They are there to comfort us when we are sad and to help us when we need them most.

Best wishes, my friends, for a long and happy life in this world. I may see you on one of the ghost walks I lead. Or I may just sense your presence sometime, on this side of heaven or the other. Good luck. Good fortune. And most of all, blessings.

REFERENCES

Akins, Kenneth L. *Medicine in Ottawa County: From 1840 until Present.* USA: 2005.

Altoff, Gerald T. *Oliver Hazard Perry and the Battle of Lake Erie.* Put-in-Bay, OH: Perry Group, 1999.

Cochrane, Hugh. *Gateway to Oblivion: The Great Lakes Bermuda Triangle.* Toronto: Doubleday Canada Limited, 1980.

Cooper, Barbara Allen. Hotel Victory. USA: 1985.

Eickert, Arius. "Ghost Stories of Sandusky County." Fremont, OH, 2010.

Feldmeth, Greg D. "U.S. History Resources." 2010. home.earthlink. net/~gfeldmeth/chart.1812.html.

Frohman, Charles E. *Rebels on Lake Erie.* Columbus, OH: Ohio Historical Society, 1965.

Horn, Kristina Smith. "Local Sites Report Possible Hauntings." *Port Clinton News Herald*, October 31, 2009.

Ohio Historical Society. "Firelands," 2009. http://www.ohiohistorycentral.org/entry.php?rec=702.

Prescott, Henry W. *Legends of Catawba*. Toledo, OH: Fred W. Haigh for Catawba Historical Society, 1922.

Roziak-Thompson, Diane. "Marblehead Histories." Marblehead, OH: 2009.

Witten, Sally Sue. *Images of America: Port Clinton, the Peninsula, and the Bass Islands*. Charleston, SC: Arcadia Publishing, 2000.

Wonnell, Marie. "Marblehead." N.d.

ABOUT THE AUTHOR

Victoria King Heinsen is a Port Clinton, Ohio native. Each year between the summer solstice and Halloween, she conducts ghost walks through her hometown for those intrepid, romantic souls who believe in the spirits all around us. A graduate of Ohio Wesleyan University, subsequently earning a master's degree at Ohio State University, Victoria is currently in the doctoral program at Walden University. She and her husband, Ed, own a bed-and-breakfast, the Marshall Inn, in Port Clinton. Victoria has been featured on Cleveland and Toledo television stations and in *Ohio Magazine*. This is her second book.

Photo by Barb Cabral.

Visit us at
www.historypress.net